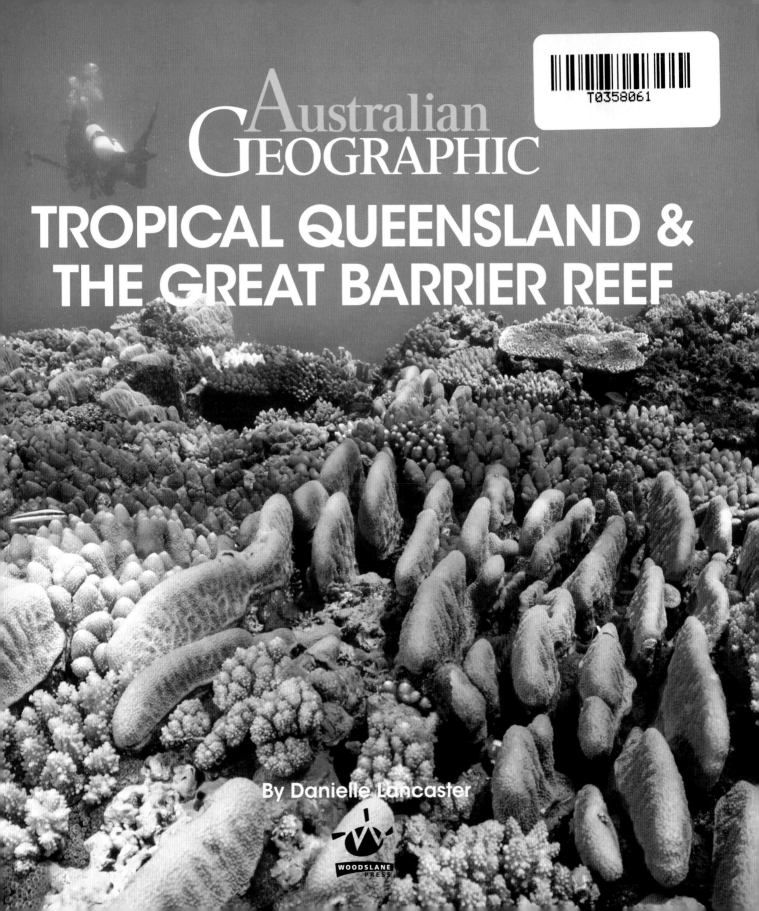

Australian GEOGRAPHIC

TROPICAL QUEENSLAND & THE GREAT BARRIER REEF

By Danielle Lancaster

WOODSLANE PRESS

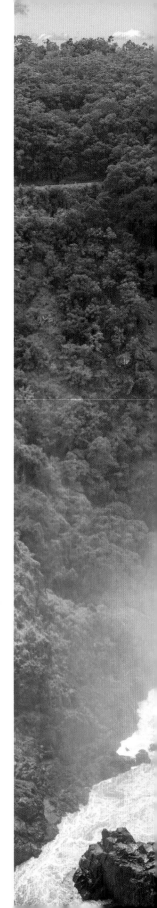

Woodslane Press Pty Ltd
10 Apollo Street
Warriewood, NSW 2102
Email: info@woodslane.com.au
Tel: 02 8445 2300 Website: www.woodslane.com.au

First published in Australia in 2019 by Woodslane Press in association with Australian Geographic
© 2019 Woodslane Press, photographs © Australian Geographic and others
(see acknowledgements on page 62)

NATIONAL
LIBRARY
OF AUSTRALIA

A catalogue record for this book is available from the National Library of Australia

Printed in China by Hang Tai Printing Company Limited
Cover image: Great Barrier Reef © Australian Geographic
Book design by: Christine Schiedel

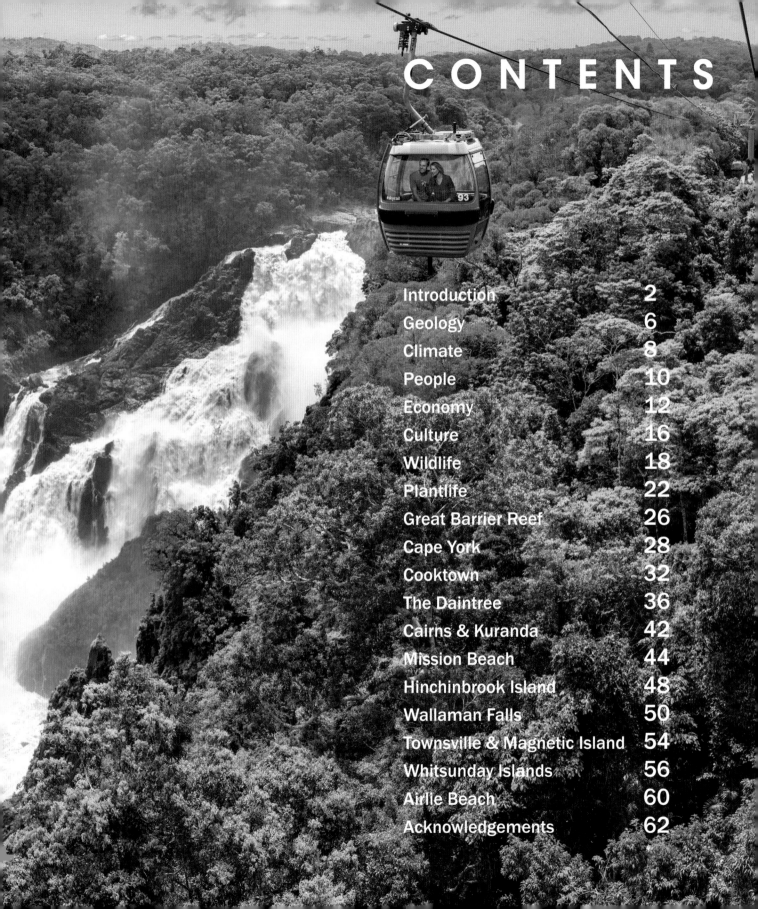

CONTENTS

ROPICAL QUEENSLAND &

Queensland's tropical north is the only place on earth where two UNESCO World Heritage-listed sites meet: rainforest and reef. North Queensland is an ancient landscape, considered one of the most exquisitely beautiful and diverse areas on planet Earth. Delicate reefs fringe tropical islands, waterfalls tumble through dense green rainforest, while on the vast savannah lands, giant termite mounds reach for the sky. Nowhere else in Australia will you see such an extraordinary distribution of plant and animal species. On land and under the water, distinct ecosystems captivate those that visit. It is indeed a special place. Whilst the rainforest is an international jewel, the Great Barrier Reef, stretching over 2,600 kilometres, is the major drawcard for the multi-million-dollar tourism industry. The dry season is the busiest time for visitors: clear skies, calm waters and most roads open, meaning it is time to explore. A dynamic indigenous presence is nurtured within strong and vibrant communities. Festivals, dances and performances continue to breathe life into the cultures of the first people to inhabit Australia. The Torres Strait Islands fringe the tip of Cape York and bring another culture to the fold. Horn and Thursday are two islands easily accessible from the mainland. With the bounties of the sea and fertile highlands so close, fresh food is guaranteed. Rolling hills swathed in plantations of sugar cane, coffee, tea and succulent mangoes, along with other produce, complement roadside stalls boasting yields straight from the farmers at bargain prices. Without a doubt, this is a place you could visit time and time again and always uncover something new.

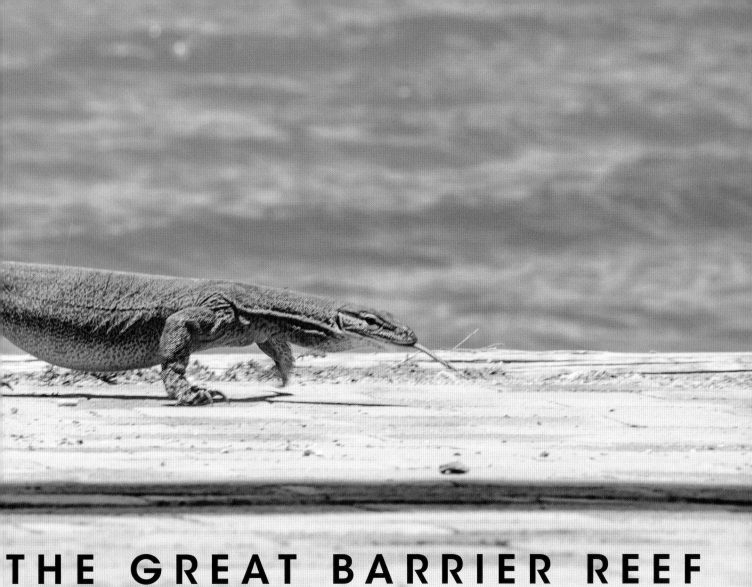

THE GREAT BARRIER REEF

Above: The tropics of northern Queensland and its adjacent isles are home to a wide array of wildlife and boast one of the most diverse ranges of animals on Earth, in and out of the water.

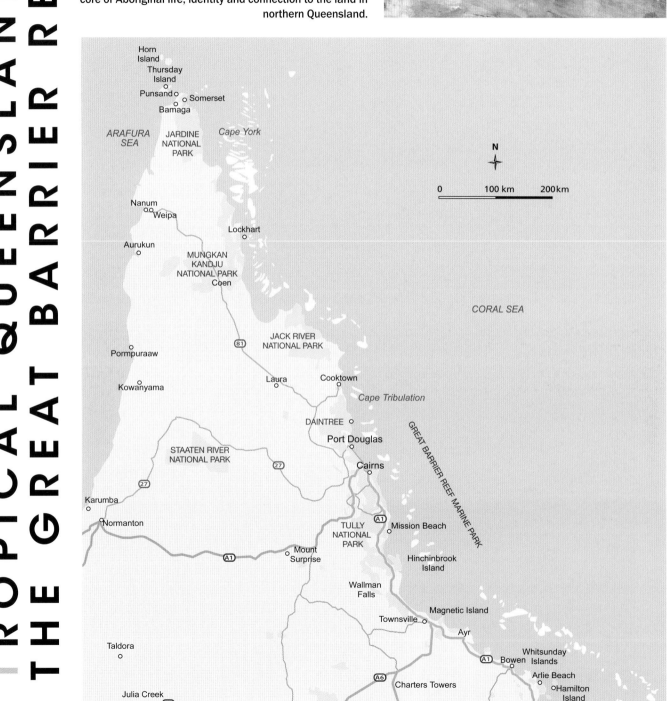

TROPICAL QUEENSLAND & THE GREAT BARRIER REEF

■ **Right:** The rock art galleries around Laura exhibit a specific style of painting and engraving called Quinkan. They are a pictorial record of ancestral spirits and represent the laws, social life, spirituality and cultural practices that are at the core of Aboriginal life, identity and connection to the land in northern Queensland.

Horn Island
Thursday Island
Punsand Somerset
Bamaga

ARAFURA SEA JARDINE NATIONAL PARK Cape York

N

0 100 km 200km

Nanum
Weipa

Lockhart

Aurukun

MUNGKAN KANDJU NATIONAL PARK
Coen

CORAL SEA

JACK RIVER NATIONAL PARK

81

Pormpuraaw

Kowanyama Laura Cooktown

Cape Tribulation

DAINTREE

Port Douglas

GREAT BARRIER REEF MARINE PARK

Cairns

STAATEN RIVER NATIONAL PARK

27

Karumba

Normanton

TULLY NATIONAL PARK A1 Mission Beach

Mount Surprise

Hinchinbrook Island

A1

27

Wallman Falls

Magnetic Island

Townsville

Ayr

Taldora

A1 Bowen Whitsunday Islands

A6

Arlie Beach

Charters Towers

Hamilton Island

Julia Creek

A6

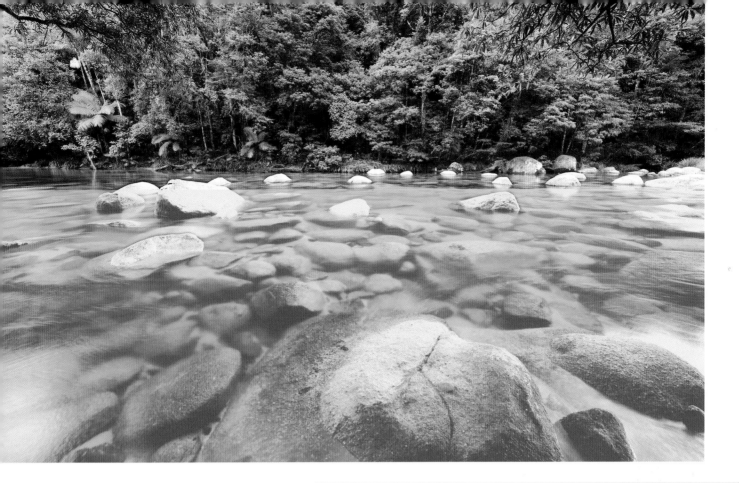

Above: The headwaters of the Mossman River, in the Daintree, were named by the explorer George Dalrymple in 1873. They rise under Devil's Thumb on the Mount Carbine Tableland then descend 1,050 metres to the ocean.

Right: The Red-Eyed Tree Frog, an amphibian, is one of the inhabitants found within the rainforest. It spends most of its time high in the rainforest canopy only venturing down after rain to breed.

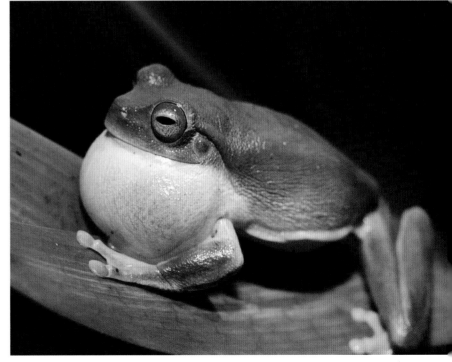

GEOLOGY

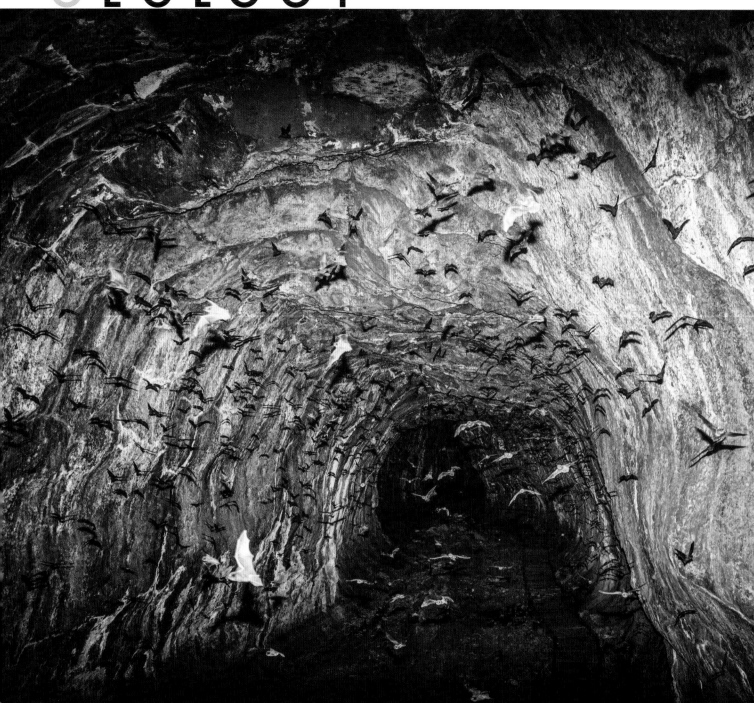

■ Above: Undara Lava Tubes, the largest and longest lava tubes on Earth and believed to be formed by extensive volcanic activity occurring around 190,000 years ago when 23 billion cubic litres of lava spewed forth from the Undara Volcano onto the surrounding Atherton Tableland.

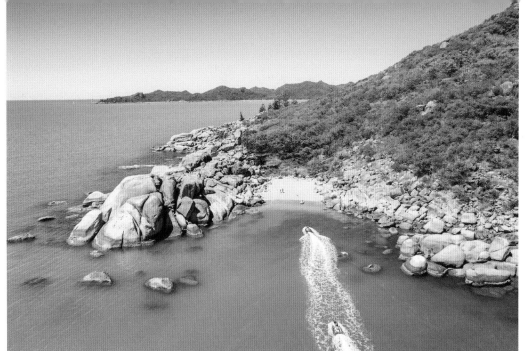

■ Above: Huge boulders, such as these on Magnetic Island, were expelled during volcanic eruptions millions of years ago.

Australia is an ancient continent, isolated for millions of years. The story in North Queensland is thought to have begun more than 420 million years ago, during an era when Australia was part of the ancient continent of Gondwana. It was a very different scene to the one you see today. Over time, rainwater has filtered through layers of rock, initiating a range of environs. Underground, rich mineral deposits were established. Volcanic eruptions have created the world's most extensive lava tube system; persistent erosion has carved and re-carved dramatic gorges with tumbling waterfalls, and strewn granite boulders around beaches and along creek beds

Rocks ultimately determine soil types and over time structure the foundation of any landscape. Enormous granite boulders on Magnetic Island support elegant hoop pines while silica sands, found on beaches such as Whitehaven in the Whitsundays, are formed from quartz that has gradually been broken down into minute pure white granules.

Rain, which can be prolific in the Wet season, moulds aquifers below the surface. Excess water spills out into streams gently nurturing the distinctive flora and flora surrounding them while massaging the land. The result is a very delicately shaped and sculptured arrangement. The region is continually changing under the influence of the tides, winds and forces of nature.

The Great Barrier Reef is a cornucopia of life, created by a long and complex process as free-swimming coral larvae attach to rocks and existing coral skeletons. Geological evidence shows that the reef first began growing more than 25 million years ago, though there have been numerous transformations to becoming the world's largest single structure made by living organisms. The reef you see today is estimated to be 6,000 to 8,000 years old and is a playground for an array of tropical fish and marine animals. Since the last ice age when sea levels rose and volcanic activity slowly subsided, the summits of Queensland's easterly coastal range become isolated into picturesque islands, a new coastline was formed, and the hinterland blossomed into a lavish fruit bowl.

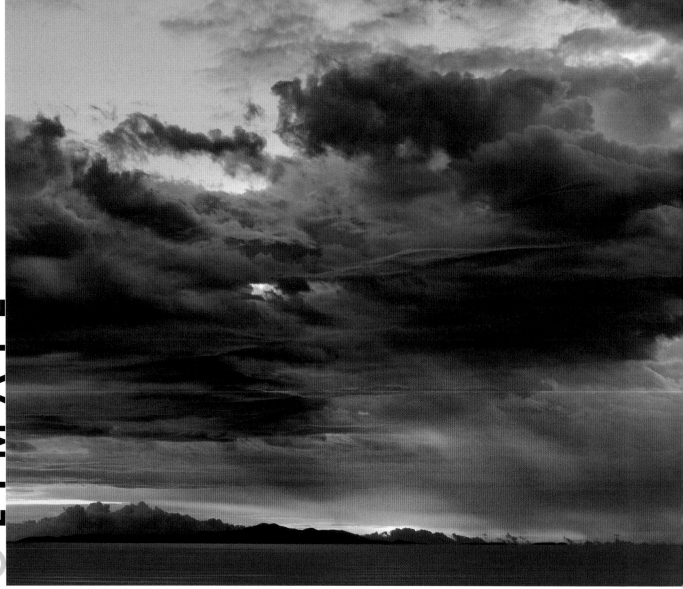

CLIMATE

■ Above: Storm clouds congregate over Palm Island.

North Queensland lies within Australia's tropical monsoon zone, meaning the region experiences two distinct seasons, the Dry and the Wet. When visiting it is imperative to keep this in mind to choose the right time of year for the activities you plan to undertake. The Wet - from November to April - brings long, warm, steamy days and a higher chance of rain. On average, 90% of the annual rainfall is received during this period. Tropical depressions delivering dramatic storms are frequent. Travel during the Wet can be difficult as roads are often closed especially through Cape York. The Dry - from May to October - is peak tourist season with sublime sunny days. Aboriginal groups break these two seasons into subgroups. Indigenous climate calendars change from group to group though they generally average between four to six seasons depending on the weather and the movement and breeding of animals and flowering of plants for food.

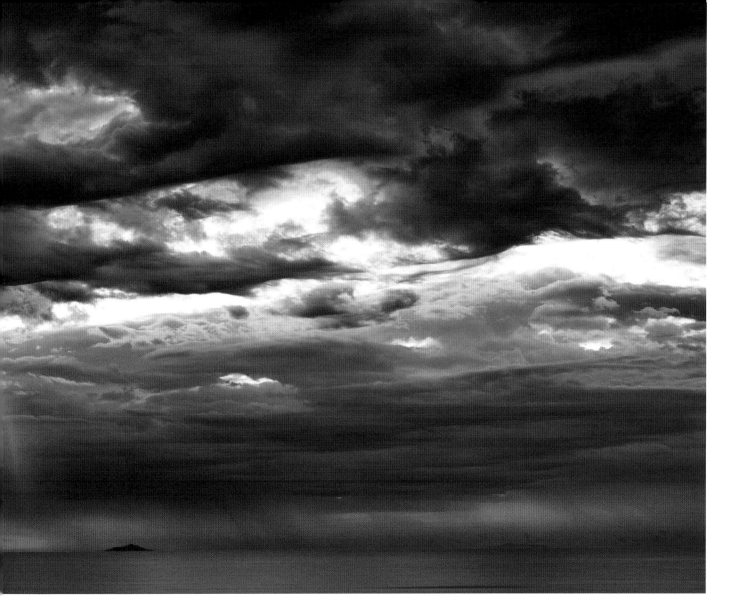

SUMMER

■ (December – February)
This is the peak Wet season with temperatures varying from 25-37°C and humidity often reaching 100%. Downpours are frequent, heavy, and typically fast, quickly decreasing the air temperatures. February is considered the hottest month. Cyclones and smaller tropical depressions may occur, though unpredictable.

AUTUMN

■ (March – May)
The skies start to clear as the monsoon troughs fade away. April is the official start of the Dry Season. Temperatures remain warm, with both day and night averaging between 21.5-29°C. The rain generally subsides from April although the weather can be windy until August. Fields of sugar cane start to flower from May to June.

WINTER

■ (June – August)
Winter sees the humidity decrease and temperatures range from 17.5-26°C. Low rainfall makes days out on the reef under clear blue skies very pleasant, with excellent snorkelling and diving visibility. The Dry season is peak tourist season.

SPRING

■ (September – November)
Temperatures range on average from 20.5°C to 29°C. The humidity slowly starts to build, heralding the onset of the Wet. Winds are typically prevailing from the south-east through to October and visitor numbers start to decrease.

PEOPLE

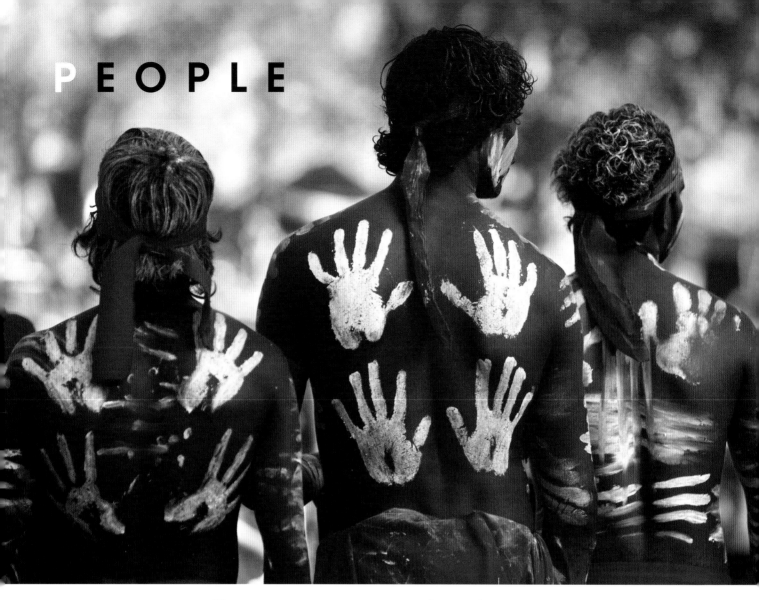

Above: It is estimated that more than 100 Indigenous groups inhabited northern Queensland before the arrival of Europeans. While many language groups are spoken, all worked together protecting the valuable resources of the land they walked on.

Right: The Jardine River is the largest river on the Cape York Peninsula in Far North Queensland. The Northern Peninsula Area Regional Council operates a safe and fun crossing of this mighty river.

Cape York, with its proximity to the islands that lie north in the Torres Strait and Papua New Guinea, is believed to be one of the first arrival routes for Australia's indigenous peoples. Rock art in the south-east Cape York Peninsula forms some of the oldest and largest galleries in the world. Around Laura, the outdoor galleries are estimated to be up to 30,000 years old and are included on the Australian Heritage Estate and listed by UNESCO as among the top 10 rock art sites in the world. Torres Strait Islanders are the indigenous peoples of the group of at least 274 islands in the strait that separates Australia and Papua New Guinea. Later, the harsh climate of northern Queensland placed many obstacles for European settlers. The indigenous peoples understood their land, how it worked and how to protect it. They were accustomed to the humidity, hot summers and rainy seasons. Dutch navigator Willem Janszoon landed near the site of the modern-day town of Weipa on the western shore of Cape York in 1606 and recorded the first encounter between Europeans and the Australian Aboriginal people well before Lieutenant James Cook sailed the coast in 1770. In the mid-1850s British settlement first started pushing beyond the Tropic of Capricorn. The settlers dreamed of developing the north into successful economic plantations as had been done in other tropical colonies. Imported indentured coloured labour came from the South Pacific and Chinese arrived following the prospect of gold. Between 1863 and 1904, around 62,000 South Sea Islanders were brought to Australia to work in the sugar industry. The Jardine brothers, Francis and Alexander, along with their father John are recognised as the first pastoralists to attempt to endure the harsh climate of Cape York when they drove 250 head of cattle from Rockhampton to Somerset in 1864. Much of this history is preserved in museums, parks and at lookouts, while sport and the arts bring another superlative layer to the people that call North Queensland home.

■ Below: Indigenous and non-indigenous tour leaders share a deep passion for the ancient and modern history of North Queensland.

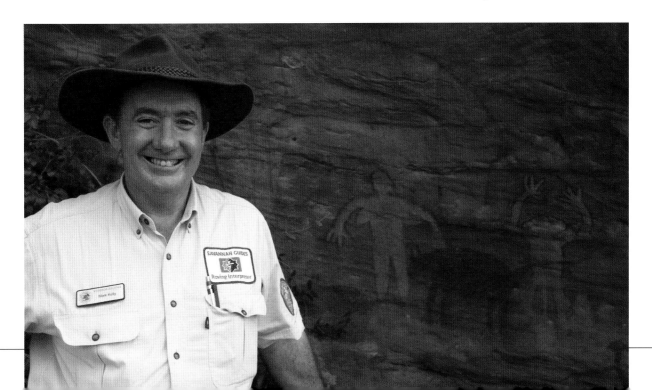

ECONOMY

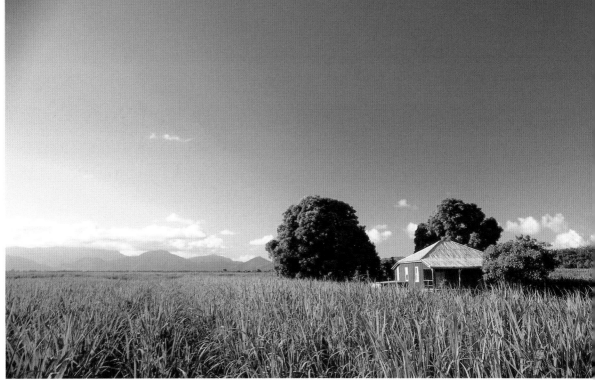

Covering over twenty per cent of Queensland, North Queensland is the largest recognised region in the state. It supports a population of approximately 300,000 which is expected to increase to 360,000 by 2036. The pastoral industry was one of the initial commercial activities to be established with cattle introduced for a beef industry. Agriculture flourished with various crops covering the fertile hinterland hills, from coffee to tea along with plantations of mangoes and avocados growing alongside towering fields of sugar cane. Gold was discovered at Cape River in 1867, and since then various mining endeavours have been made, some less successful than others. Charters Towers was renowned as Australia's richest goldfield for a spell and was once called 'The World', operating its own stock exchange: over 6,000,000 ounces of gold were mined in the first 40 to 50 years. Mining is still valued at more than $700 million per annum with bauxite a major commodity, contributing 10% of the world's production. The Weipa bauxite operation exports over 30 million tonnes of bauxite annually and is a significant employer of Aboriginal and indigenous Australians. The region has also produced tin and other base metals such as nickel, tungsten, kaolin, antimony and silver along with gemstones. Tourism, a substantial contributor to the economy, creates around 18% of jobs and earns in excess of $2.5 billion of gross regional product. North Queensland is the gateway to the Great Barrier Reef and Wet Tropics and has become a mecca for both Australian and international tourists, welcoming around 2.7 million visitors each year. Indigenous tourism has also grown substantially over the past decade, developing a myriad of tourism experiences.

Above: First grown in Australia in 1788, sugar cane is a perennial grass and North Queensland is the perfect environment for this agricultural enterprise. Sugar is just one by-product: there is also rum, stockfeed and fertiliser.

Left: Fields of tea grow in the fertile hinterland.

CULTURE

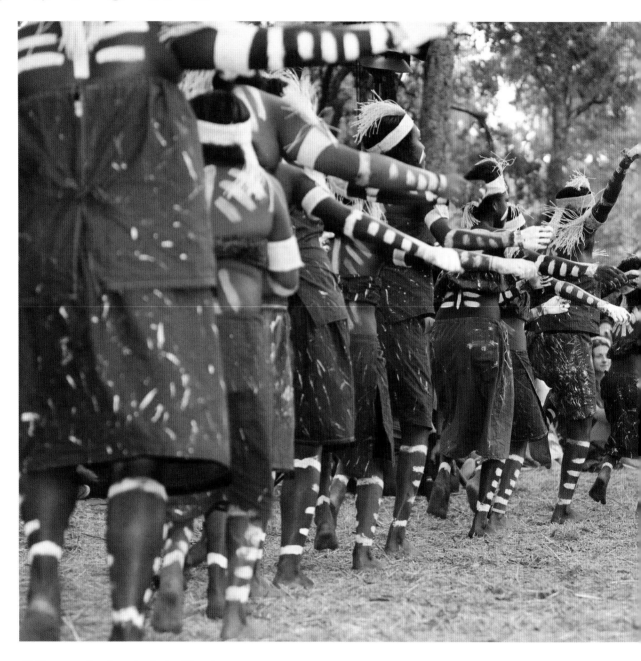

■ Above: On the grounds of a traditional and sacred Bora ground, communities of Aboriginal and Torres Strait Islanders come together every second year for the three-day Laura Dance Festival celebrating dance, singing and cultural performances.

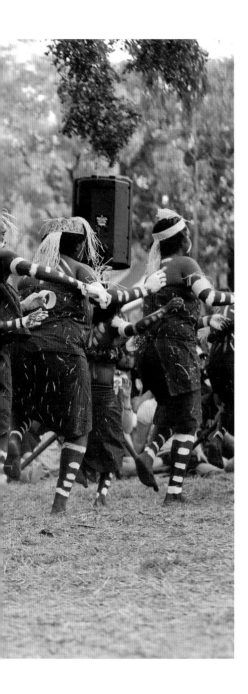

An exciting feature of visiting North Queensland is experiencing the only place in Australia where two indigenous cultures - Aboriginal and Torres Strait Islanders - converge. One of the many delights for any guest to 'country' is taking time to engage themselves in the rich tapestry of their unique and delicate cultures. When Aboriginal people use the English word 'country', it means more than just the land. Culture, nature, people and land are all interwoven and each community has a special connection and distinct laws and traditions. 'Country' combines stories, seasons and spirits as it is a place of belonging, a way of believing and life. In North Queensland 'country' is still an essential part of their custom. Attend a ceremony, and you will hear a 'Welcome to Country'. This is usually presented by an Elder and can take various forms, from, singing to dancing, smoke ceremonies or a speech. For all the people, everything has a meaning and profound importance. Stories, practises and ceremonies have been handed down generation after generation and centre around the Dreamtime, an intricate part of the indigenous culture which focuses on not only the past but also the present and future. There is a serenity and harmony with nature when you sit by Mossman Gorge for a time-honoured smoking ceremony or wander through a national park with an indigenous ranger discovering the uses of native foods and why men can only visit some areas and women others. The people are proud and nurture the knowledge relating to their ancient culture. Art, as in the past, continues to play a vital function in the expression of the North Queensland indigenous culture. The Cairns Indigenous Art Fair, held each July, attracts artists from throughout the region. Dance like art has always been a meaningful way to tell stories. North Queensland, with its wealth of culture to experience from the ancient past to modern day, is an encounter not to be missed.

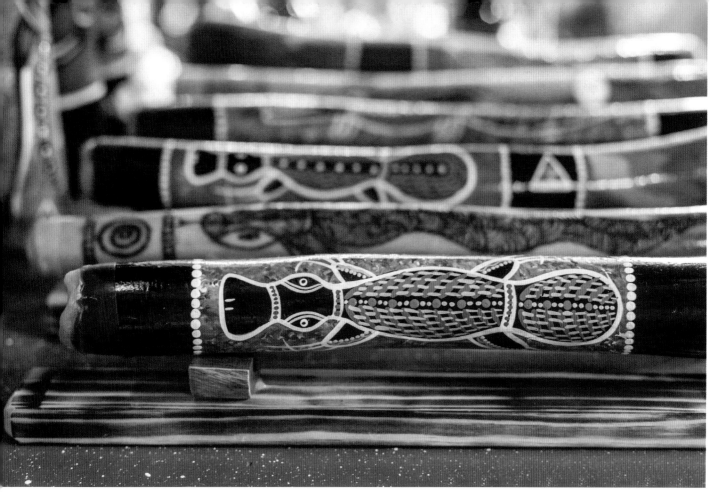

Above: Artworks, traditional to modern, depict ancient traditional stories.

Left: Native foods from the bush are still traditionally used for food and medicine.

Far left: Smoking ceremonies are performed as a welcome to 'country'.

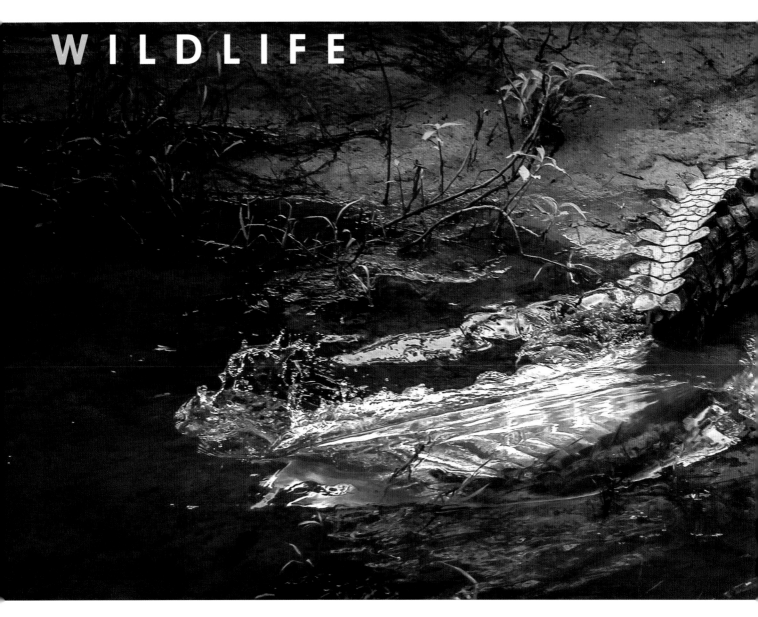

WILDLIFE

The rainforests and grasslands of North Queensland have evolved into incredibly diverse ecosystems. There are 400-plus bird species and 100-plus mammals, many found nowhere else on earth and some that the region shares with only our closest neighbours: for example, Cape York boasts many kinds of animals also found in Papua New Guinea including two Birds of Paradise – the Magnificent Riflebird and the Trumpet Manucode.

One of the best-known animals of the region is also one of the most ancient: the saltwater crocodile, which inhabits billabongs, rivers, creeks, beaches, swamps and a range of estuaries. Signs warn you not to swim or venture too close to a riverbank. Another famous north Queensland resident is the Southern Cassowary, which can grow to two metres in height and weigh up to 76 kilogrammes, heavier than the emu. With a brilliant blue neck, drooping red wattles and unusual helmet, it is a spectacular bird, often referred to as the gardener of the rainforest as it busily rakes the floor spreading seeds.

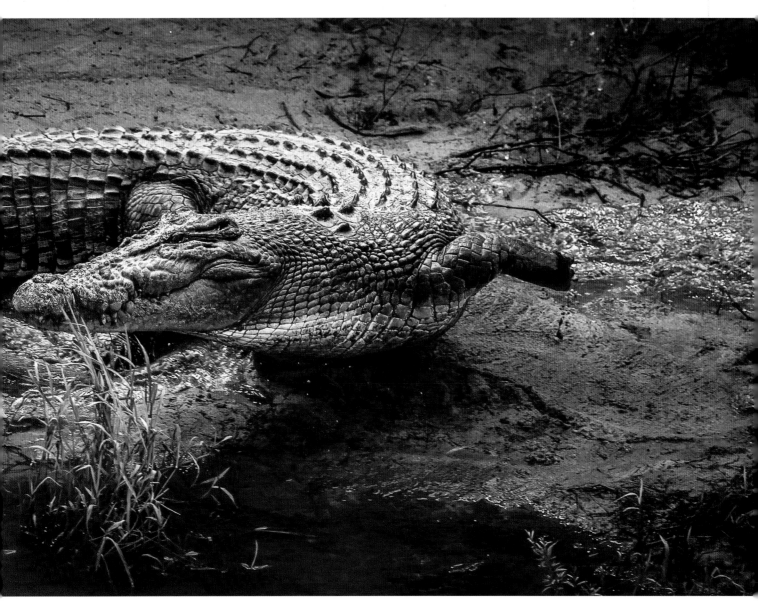

Above: Considered one of Earth's fiercest predators, the Saltwater (or Estuarine) Crocodile is the world's largest living reptile species. Simply referred to as 'Salties', they are able to hold their breath for up to an hour underwater, in which they are able to see surprisingly well thanks to their special transparent eyelids.

Left: The Feathertail Glider is the smallest gliding mammal in the world.

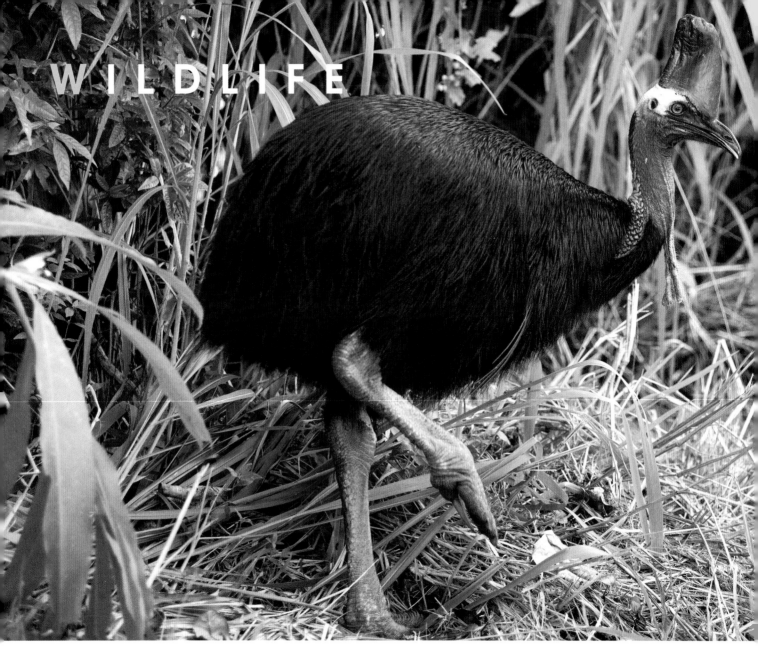

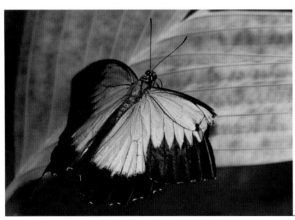

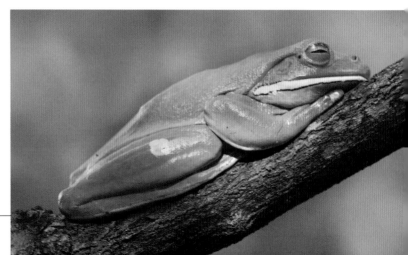

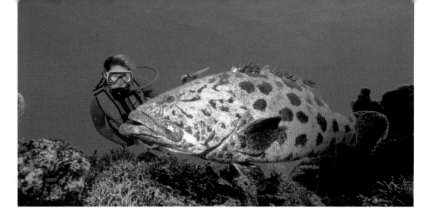

As well as a wealth of reptiles, mammals, birds and invertebrates the region boasts at least 64 frog species. The unique untamed and wild wilderness means that some species have only been recently discovered, such as the Cape Melville frog found in 1997.

Then there is the ocean. The Great Barrier Reef, the world's largest coral reef system, is composed of over 2,900 individual reefs and consists of 411 types of hard coral and one-third of the world's soft corals. A reef is a colony made up of thousands of invertebrate animals called polyps and their ancestor's skeletons. Stretching for over 2,300 kilometres the reef system supports more than 1500 species of fish, over 130 species of rays and sharks, six of the world's seven threatened marine turtles and the odd-looking marine mammal, the dugong.

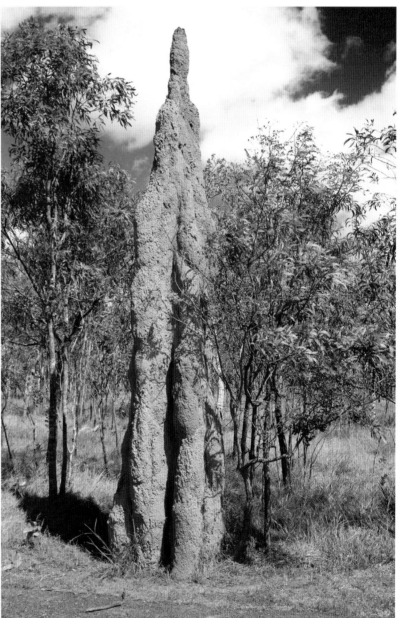

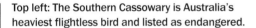

Top left: The Southern Cassowary is Australia's heaviest flightless bird and listed as endangered.

Bottom far left: The wet tropics world Heritage area contains over 60% of Australia's butterfly species including the beautiful swallowtail Ulysses butterfly. Although they are easy to identify due to their bright blue colouring, they are also easily to spot by their predators and fly very quickly and erratically making them hard to photograph! It is found in most tropical rainforest areas of Northern Queensland.

Bottom left: The White-lipped Tree Frog is the world's largest tree frog reaching lengths of 14 cm.

Top right: Visible from outer space and World Heritage protected, the Great Barrier Reef supports a multitude of corals, fish, reptiles and invertebrates.

Right: The 'magnetic' termite mounds of far northern Australia are spectacular but what intrigues all is how these tall, mounds align in a north to south direction. Termites are found on all continents, but magnetic mounds are natural wonders of the tropical Australian landscape.

PLANTLIFE

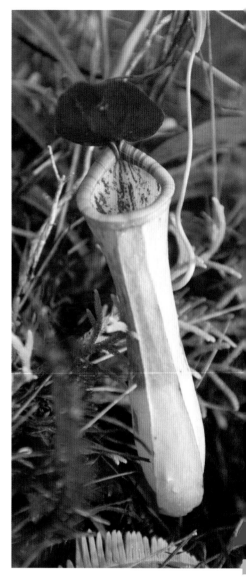

Within the varied and distinctive landscape of North Queensland, the plant life is as diverse as the animals. Already over 3,000 different species have been identified and it is predicted more will be discovered in the future. Queensland is said to be the most diverse state in Australia for flora. The mixture of rich soils, high rainfall and warm temperatures provided by the wet tropics prepares an ideal habitat, supporting over 2,800 plants from 221 families. Thirty per cent of Australia's orchids, 65 per cent of the country's ferns and 21 per cent of cycads are found in the region. Many are threatened, creating a very special wild nursery. Parasitic and carnivorous plants are two other fascinating forms of plant life. Parasitic plants, like the Mistletoe and Strangler Fig, are spread by bird droppings and start their early life high in the rainforest canopy gaining water and nutrients from the host tree. The notched sundew, a carnivorous plant, is endemic and only occurs on Bartle Frere, Queensland's highest mountain, near Cairns. Ferns are one of the oldest identifiable plant types, dating back to more than 325 million years. Mangroves have adapted proficiently to the sea water with their root systems specialists at filtering out salt. Of all the plants the one that makes you feel you are really in North Queensland is the palm tree. Palms, one of the earliest types of flowering plants, are estimated to have been around for 55 million years, if not longer. Fungi, lichens, eucalypts, acacias, pretty water lilies and grasses all add to the array of complex vegetation systems within the area.

The savanna is a striking contrast to the rainforest. Grass trees with their mops of spiky foliage are common in woodlands and can live up to 600 years. Plant life is not confined to the land. Meadows of seagrasses, algae (seaweed) and sea lettuce provide oxygen and nutrients to the animals underwater. Marine turtles and dugongs dine on the rich seagrass beds, while one of the most important plants in the Great Barrier Reef is a type of algae called Crustose coralline. In its crucial role it helps the coral reef grow by releasing sediment that acts as a sort of glue to hold together the layers of limestone. Plants have played an essential part in the indigenous culture with fruits, seeds, roots, leaves and bark used for a variety of purposes from food to medicine, utensils and even the construction of canoes. Many restaurants use bush tucker on their menus. Barramundi smoked in paperbark, seasoned with Australian Lemon Myrtle has become a favourite for visitors.

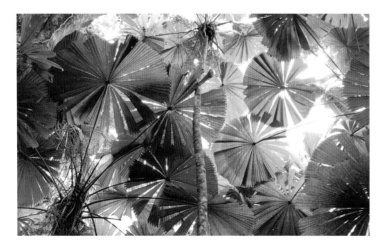

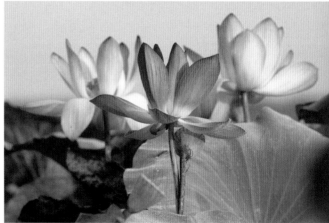

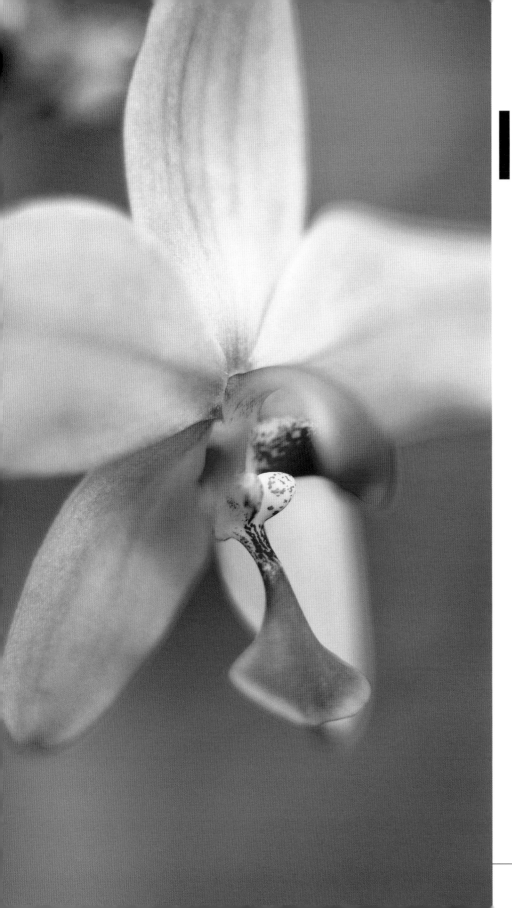

Left: On 19 November 1959, the Cooktown Orchid was proclaimed as the floral emblem of Queensland. These plants grow up to 80 cm in height and have 3-20 flowering canes up to 1.5 cm in diameter. Occurring naturally in northern Queensland, from Johnston River to Iron Range, the orchids will grow and flower almost anywhere, with flowers averaging 3 to 6 cm wide and usually coloured deep to pale lilac. The white flowering orchid is very rare.

Top opposite page: The pitcher plant, a carnivorous plant, is easy to identify. It has a long, narrow receptacle filled with fluid which digests insects (or even slightly larger animals).

Opposite page, bottom left: Lillies bloom across billabongs and waterways.

Opposite page, bottom right: Fan palms, also known called Australian Fan Palm or the Licuala Palm, are endemic to Queensland's northeast Wet Tropics area from Cooktown and south to Ingham.

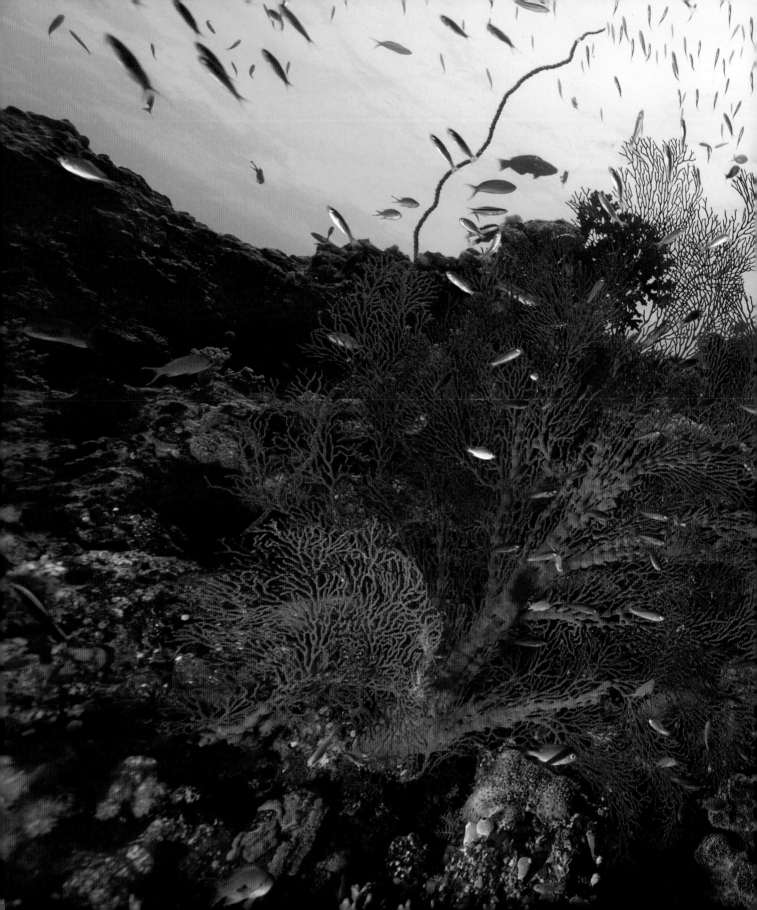

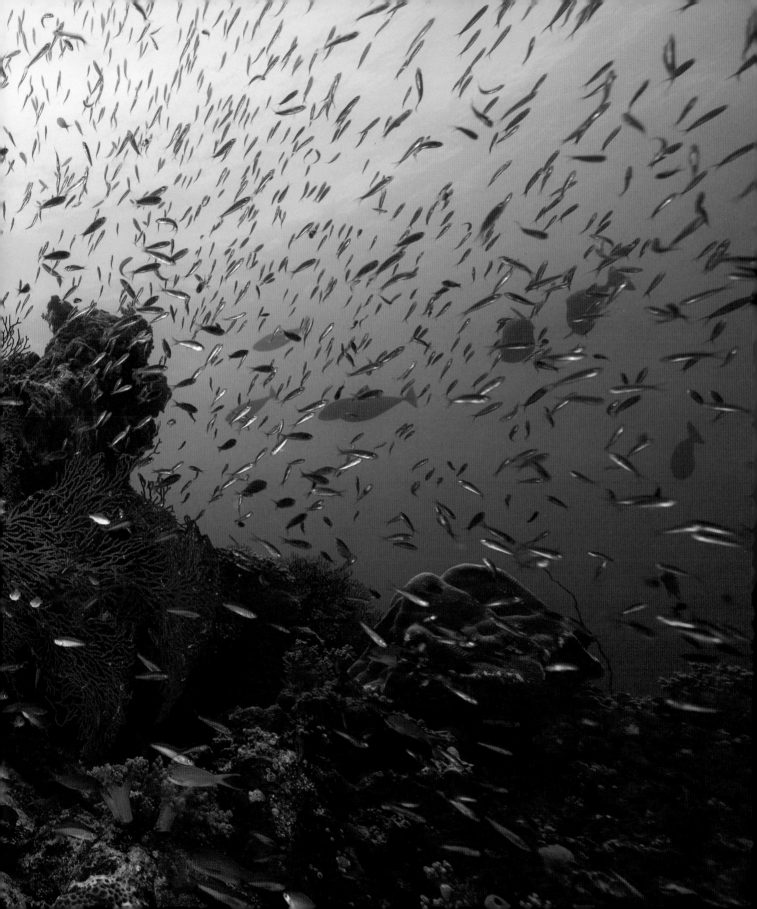

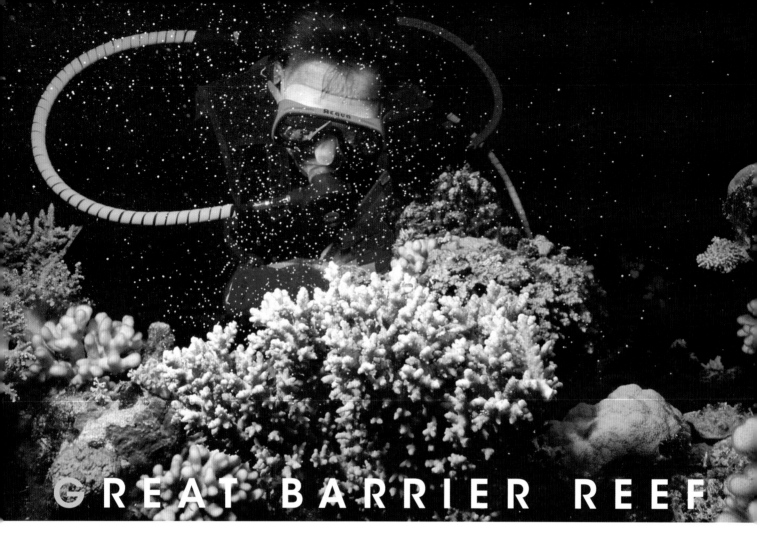

GREAT BARRIER REEF

The world's largest coral reef is visible from outer space and well worthy of its UNESCO World-heritage listing in 1981. Covering 348,000 square kilometres from Bundaberg to Cape York this matchless underwater environment is one of the richest and most diverse natural ecosystems on planet earth. An irreplaceable slice of nature, the reef consists of more than 2,900 separate coral reefs and is dotted with 600 continental islands, 300 coral cays and around 150 inshore mangrove islands. Each of these sustain myriad animals and plants which live both under and above the water. To date the list is staggering: 1,625 tropical fish species, 133 types of sharks and rays, at least 3,000 varieties of molluscs, over 500 species of worms, 30 species of whales and dolphins, 630 types of echinoderm (starfish, sea urchins), 14 breeding species of sea snakes and giant clams that have been lying on the seabed for over 120 years. Out of the water there are 215 species of birds including 22 seabirds and 32 species of shorebirds inhabiting the region. Nutrient-rich seagrass beds maintain one of the world's most important dugong populations and six of the world's seven species of marine turtle. This remarkable gift from Mother Nature, one of the seven wonders of the natural world, is undeniably exceptional and unrivalled. A wealth of corals gives the reef its remarkably vivid and intense colours. Two main types of coral - hard and soft - form the reef system. While they look like plants, they are tiny, minute colonies of animals called coral polyps which, surprisingly, are related to jellyfish. This internationally renowned icon is a captivating underwater haven from above and below the water.

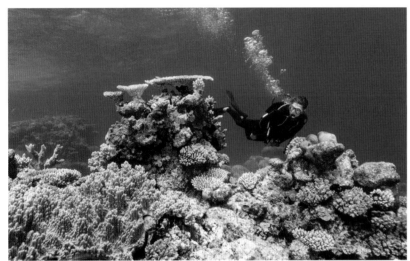

Opposite page: Sex on the reef is an occasion for a party, as it only happens once a year. Each November, hard and soft corals spawn in an underwater 'snowstorm' as the corals erupt into a new cycle of life, and a new cycle for the reef.

Top left: Corals are not plants but animals. Soft corals, (as pictured) lack a solid skeleton, are flexible and supported by tiny limestone spike-like structures called spicules.

Left: Receiving world heritage status for its 'outstanding universal value', the Great Barrier Reef was the first coral reef ecosystem in the world to be given this distinction.

Below: Turtles inhabit the reef all year-round. The females come ashore only once a year from November to January to lay their eggs for the next generation.

Previous page: A world acclaimed marine playground, the Great Barrier Reef fosters an incredible collection of animals, plants, atolls and cays.

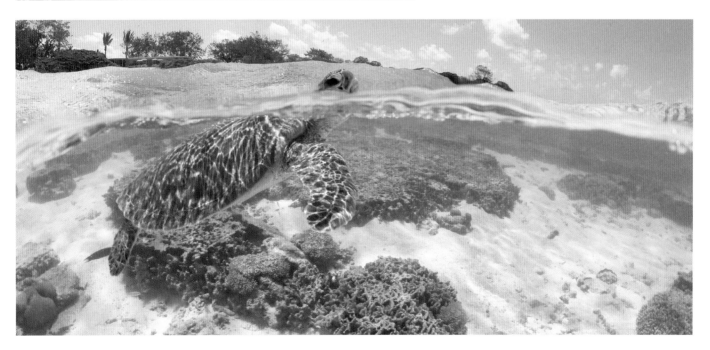

CAPE YORK

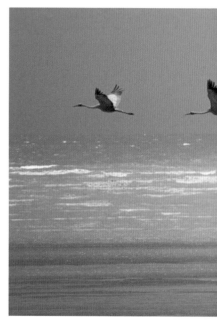

The most northern point of Australia is one of the most remote, isolated and stunning landscapes in Australia. Bracing a 180 million-year-old history, this wilderness is also affectionately called 'the Tip'. Due to its proximity to the isles to the north (with which it was connected as little as 12,000 years ago), Cape York has evidence of one of Australia's longest human histories. North of the Jardine River, the peninsula tapers, with the Coral Sea to the east and the Arafura Sea and the Gulf of Carpentaria to the west. The Tip is a place where you can become immersed in a fusion of cultures, with around 20 different communities calling this area home. As the largest unspoilt wilderness in eastern Australia, there is a wealth of wild rivers, waterfalls, fantastic flora and fauna in and out of the water, island communities and cultural experiences.

Cape York boasts the largest diversity of fish species in Australia making it a mecca for anglers. The self-drive trip to Cape York has become a classic Australian four-wheel drive journey, while tours ferry people in and out by road, air and sea. It is estimated more than 20,000 now make the trip to the Tip every year. Careful consideration and planning should be undertaken before attempting the drive as this is a rugged and untamed region. The roads are rough and often inaccessible especially during the Wet season - but it's well worth the effort. Alcohol restrictions apply within the Northern Peninsula Area no matter how you are travelling. The region includes the Torres Strait Islands, a group of 274 small islands of which 14 are settled. Thursday and Horn Islands remain the most visited from the mainland on day trips.

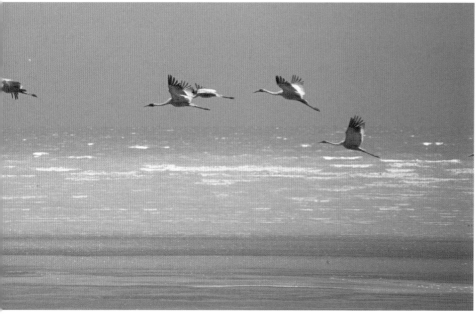

Above: The Peninsula Developmental Road.

Left: Brolgas, an Australian crane, fly above the sea along the peninsula.

Following page: The Tip of Australia lies only 128 kilometres south of Papua New Guinea, Australia's closest neighbour.

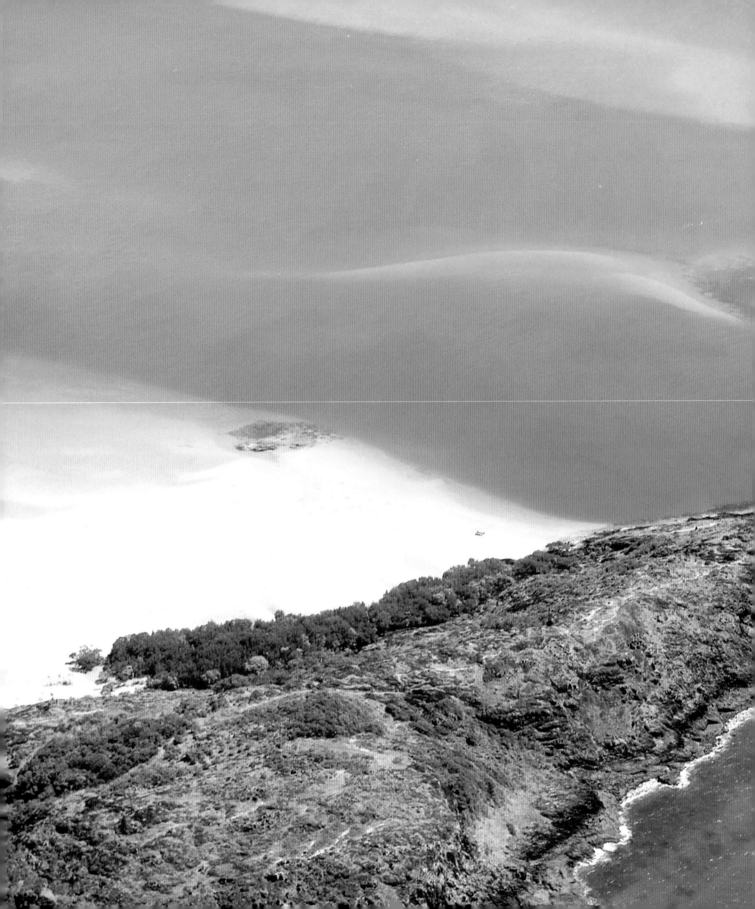

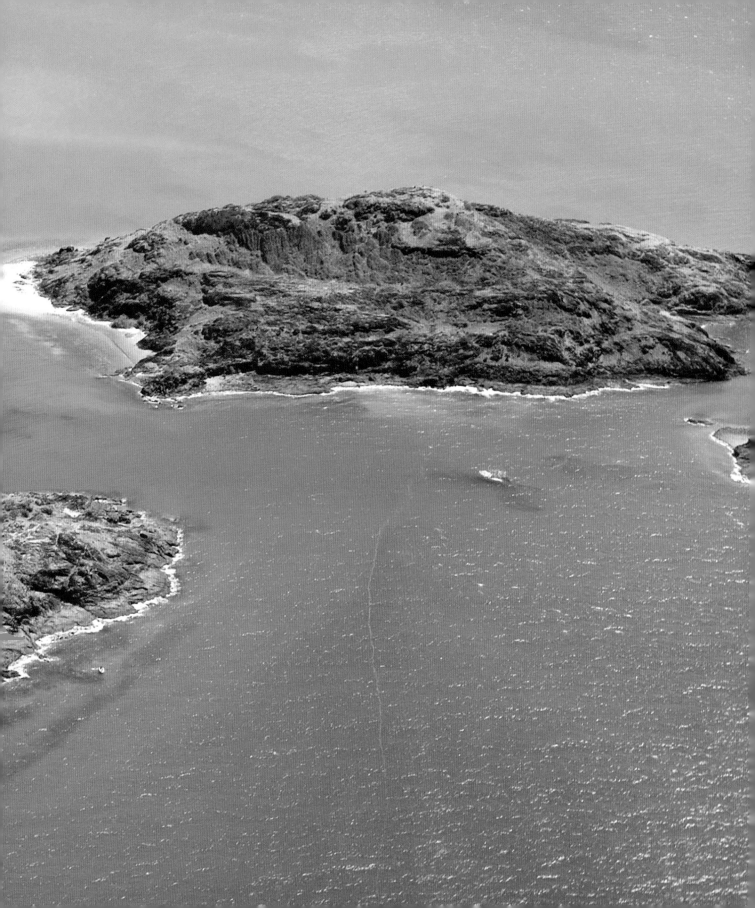

COOKTOWN

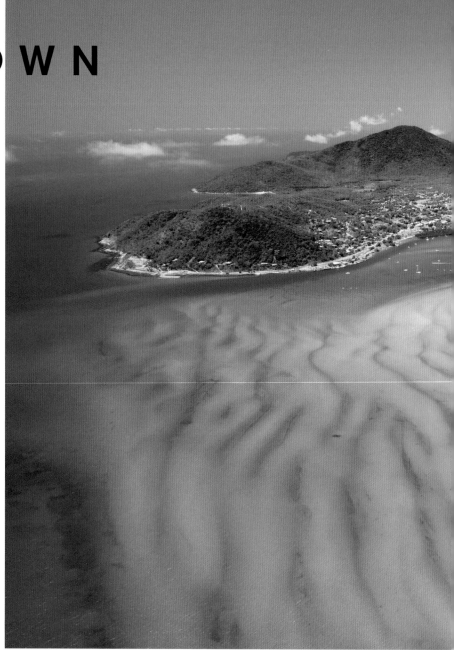

Cooktown is sited on the Endeavour River, the only river in Australia named by Lieutenant James Cook (later Captain Cook). Cook made landfall in 1770 here because his ship, HMS Endeavour, needed urgent repairs after running aground on the reef. It was his longest onshore stay during his entire voyage. Originally called Cook's Town, it was renamed on 1 June 1874. Today this is a town of friendly locals with a population around 2,300. You can reach Cooktown by three ways: self-drive or on a tour on the 4WD-only route through the Daintree, Cape Tribulation and Bloomfield, driving the fully sealed Kennedy Highway from Cairns to Mareeba then the Mulligan Highway, or a scenic flight from Cairns from which you'll see the Daintree, islands and beaches from the air. Cooktown has a colourful history. There are six monuments in town dedicated to Captain Cook including the Cook Monument and a cannon built in 1887 which had nothing to do with Cook. It was placed in town in 1885 because of fears of a possible Russian invasion. From Grassy Hill, named because the local Aboriginals deliberately burnt the forest on the hill to encourage re-growth of vegetation and draw animals for hunting, you will find the best views over the Endeavour River and township. The Lion's Den Hotel, on the Bloomfield Track, built in 1875 is surrounded by shady mango trees dating back over 100 years and is one of the many popular day trips from Cooktown. The town remains a peaceful, attractive coastal town encircled by stunning scenery and is Australia's closest town to the Great Barrier Reef.

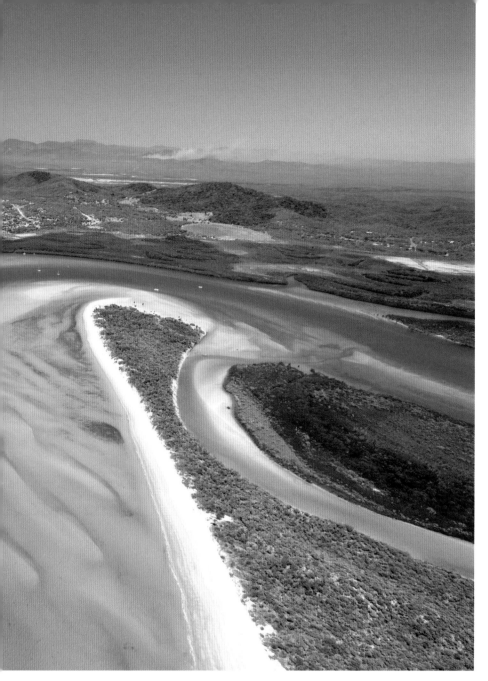

Left: Cooktown sits sheltered at the mouth of the Endeavour River.

Opposite page, bottom: Each year in June the town celebrates the landing of James Cook and his friendly meeting with the Guugu Yimithirr people with the three-day Cooktown Festival.

Below left: Giant black granite boulders, some the size of houses, provide a home to unique wildlife and a rich Aboriginal culture in Kalkajaka National Park, previously known as Black Mountain, south of Cooktown.

Below: The historic Cooktown Hotel, is an icon of this friendly seaside town.

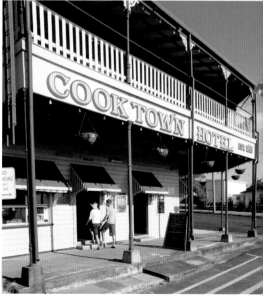

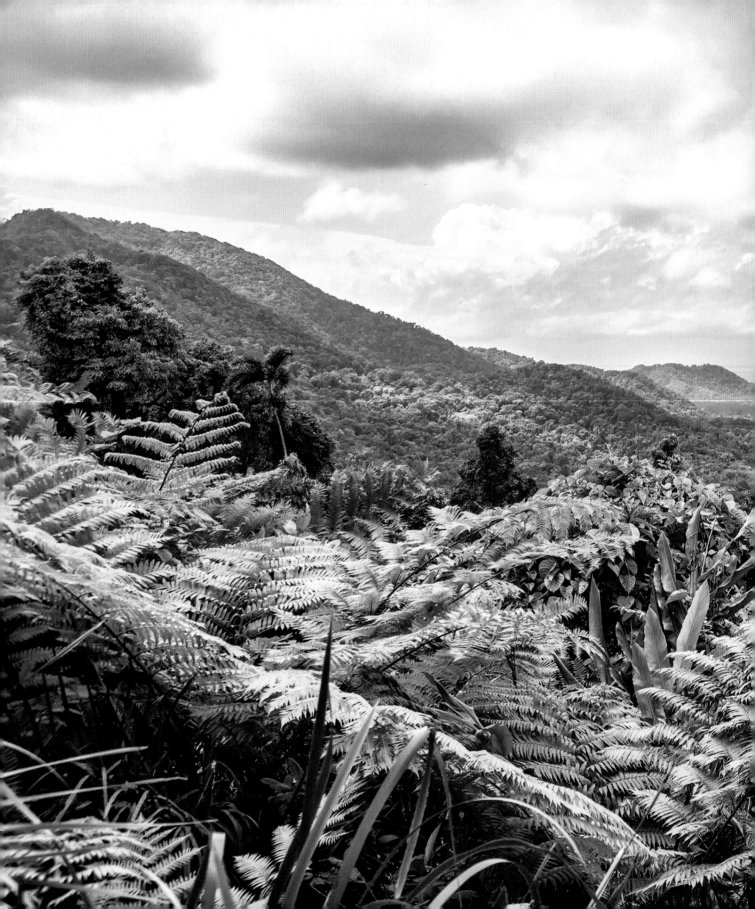

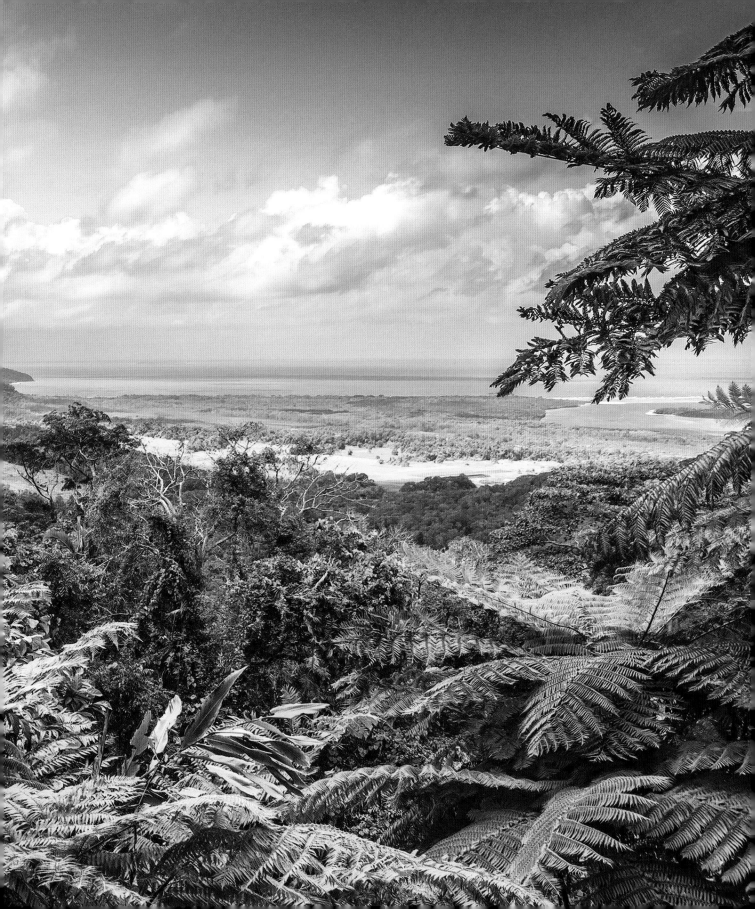

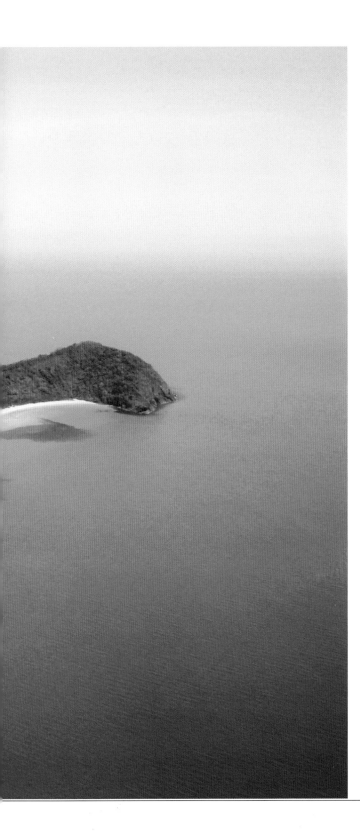

Cloaked in every shade of green, the UNESCO World Heritage-listed Daintree Rainforest is one of the three oldest intact tropical rainforests in the world and the largest continuous area of tropical rainforest in Australia. It harbours Australia's richest diversity of flora and fauna and numerous rare plants and animals found nowhere else. Of the 19 primitive flowering plants, 13 survive only in this one section of primordial rainforest alone. It also harbours 28% of Australia's frog species, 65% of its ferns, 40% of its birds and 34% of the country's mammals – and no doubt more will be discovered. Encompassing 1,200 square kilometres the rainforest starts at Mossman Gorge, continuing north past Daintree Village, across the Daintree River and through the Daintree National Park to Cape Tribulation, then along the Bloomfield Track towards Cooktown. The traditional custodians are the Kuku Yalanji people. George Elphinstone, an early explorer, named the region after his friend Richard Daintree, a pioneering Australian geologist and avid photographer.

■ Left: The enchanting Cape Tribulation headland is where two national treasures meet – the Wet Tropics and the Great Barrier Reef.

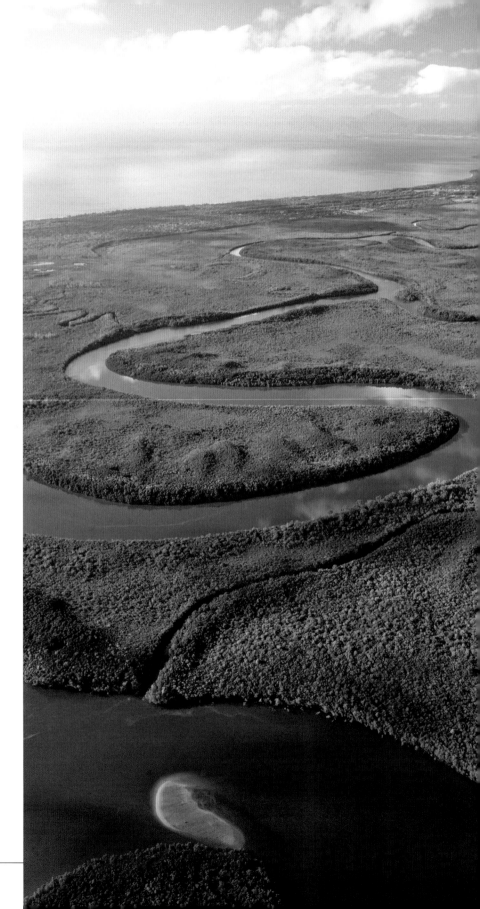

Right: Weaving through the pristine ancient rainforest to the coast, the Daintree River supports a dazzling array of wildlife along its 140-kilometre route.

Opposite page top: A prehistoric forest, the Daintree is one of the oldest forests on earth. The Daintree Discovery Centre, an award-winning world-class interpretive facility, is a great place to start your journey. It offers an engaging outing into the richness of the area through its long history, flora and fauna.

Opposite page bottom left: Heliconia, also known as lobster-claw, is one of the most colourful flowers of the forest and has become a favourite for home gardeners in the tropics. Their large bracts almost hide the flowers altogether keeping the sweet nectar so that only specialised birds can feed on it.

Opposite page bottom right: The pretty Azure Kingfisher, also found in Papua New Guinea and Indonesia and one of the smallest in the kingfisher family, catches its prey while plunging into the water.

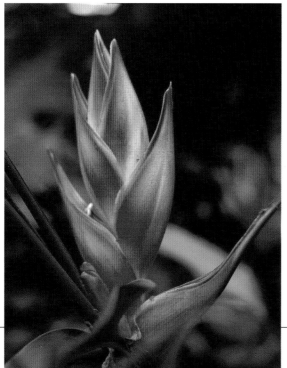

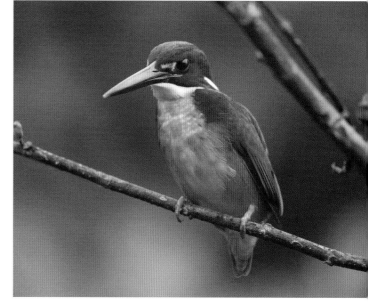

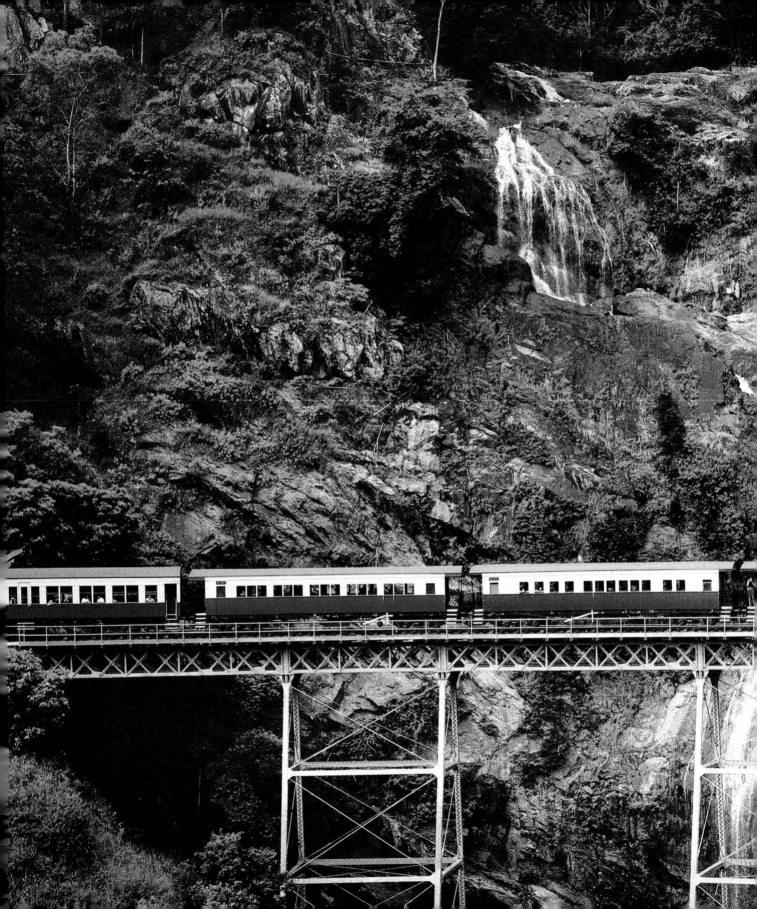

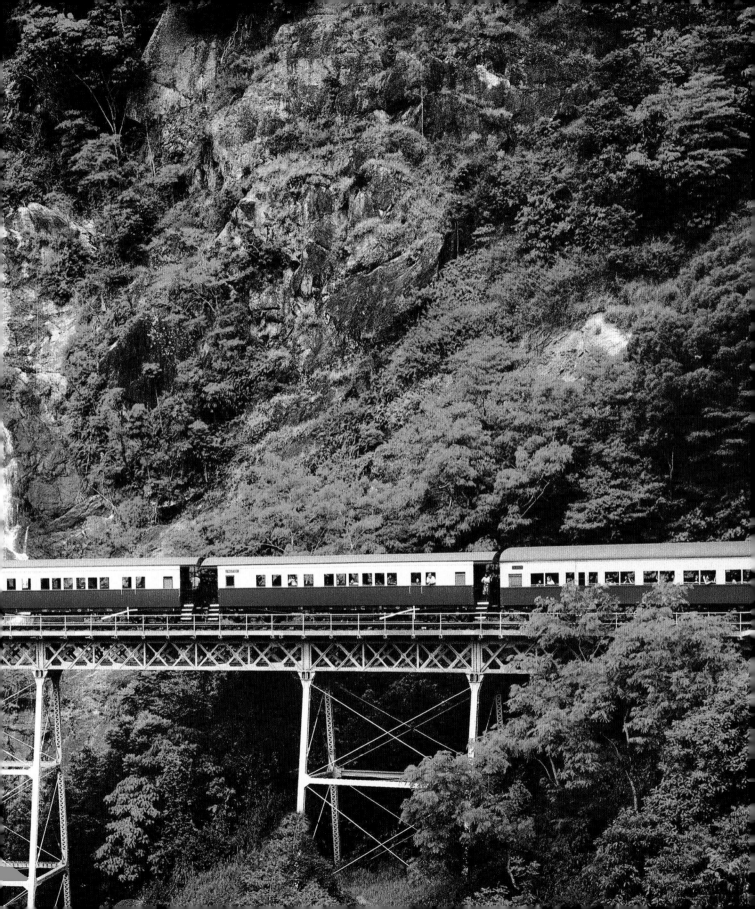

CAIRNS & KURANDA

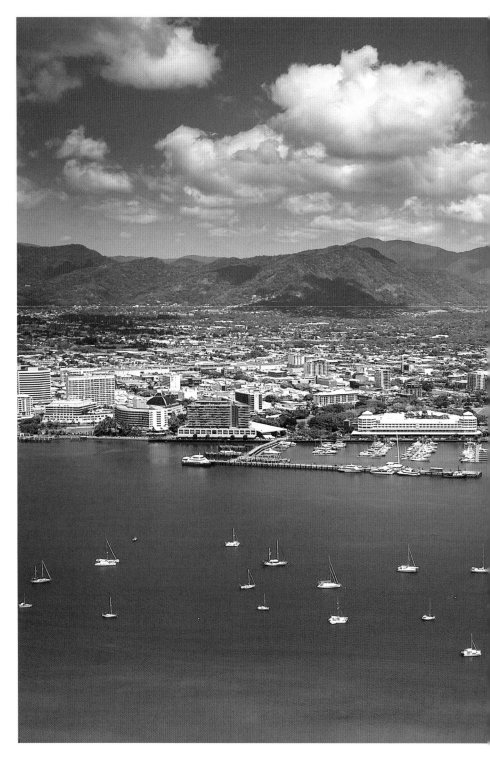

Named in honour of Sir William Wellington Cairns, the State Governor of the day, Cairns was founded in 1876, following the discovery of gold, and formally declared a town in 1903. Within and around the city there has been a multitude of exciting and diverse opportunities developed to grow tourism and agriculture, notably since Cairns opened an international airport in 1984. Day-tripping from the city offers many exciting opportunities with both the reef and rainforest nearby. Tranquil beaches such as Yorkey's Knob, Trinity Beach and Cairns' most northern beach, the aptly named Palm Cove, are a short drive from the city. Nearby Kuranda, surrounded by tropical rainforest, has been the home to the Djabugay people for over 10,000 years. The journey to this picturesque village is an adventure in itself: you can either self-drive through the rainforest, float above the trees aboard the cableway, or catch the Kuranda Scenic Railway. Renowned for its markets, the Australian Butterfly Sanctuary (the largest butterfly flight aviary in the Southern Hemisphere) is also located in the heart of the village. The Atherton Tablelands, west of Cairns, is the food bowl of north Queensland. Plantations of tea, coffee, sugar cane, tropical fruits and areas of protected wilderness roll up and down the lush hills and valleys. The region covers an area approximately 65,000 square kilometres and has a less humid climate to the coast being 500-1,000 metres above sea level.

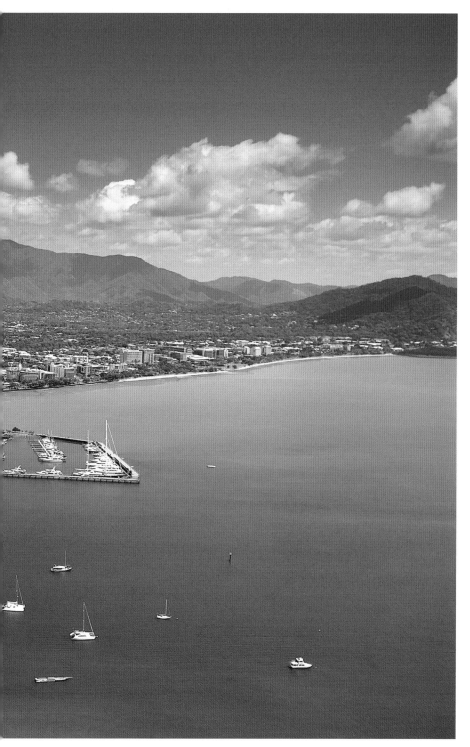

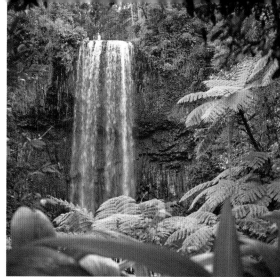

Left: A vibrant city, Cairns is Queensland's 5th most populated.

Top: Millaa Millaa Falls, a heritage-listed plunge waterfall south of Cairns.

Above: A red Beehive Ginger in the Flecker Botanic Gardens. The gardens, first established in the 1880s, are heritage-listed and the only wet tropic botanic gardens in Australia.

Previous page: Rising 328 metres, the Kuranda Scenic Railway weaves its way through World Heritage protected tropical rainforest, past spectacular waterfalls and into the Barron Gorge. Officially opened in 1891, the railway's construction was an engineering feat of tremendous magnitude for the time.

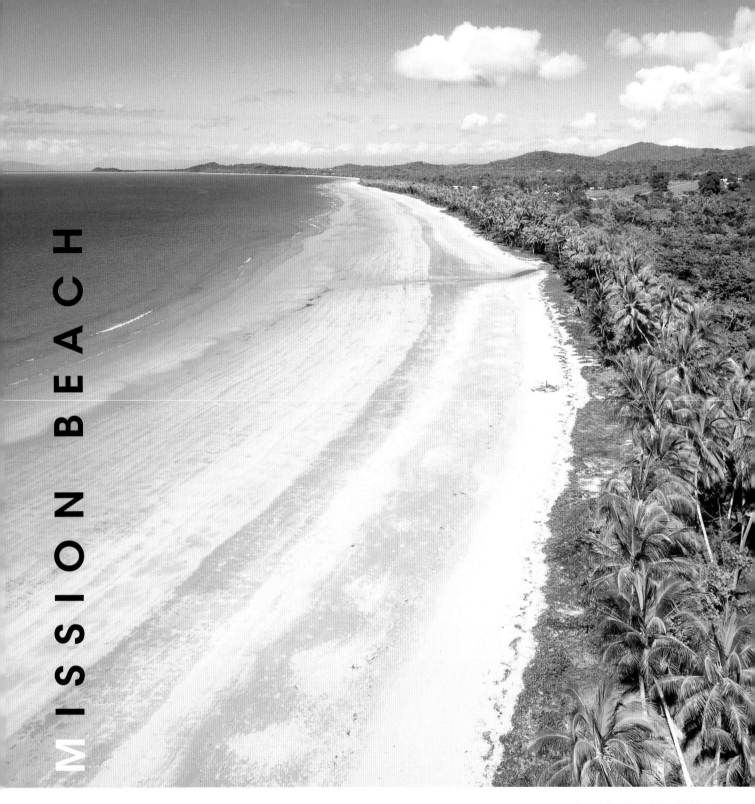

MISSION BEACH

Above: Beaches fringed with palms lead from village to village along Mission Beach.

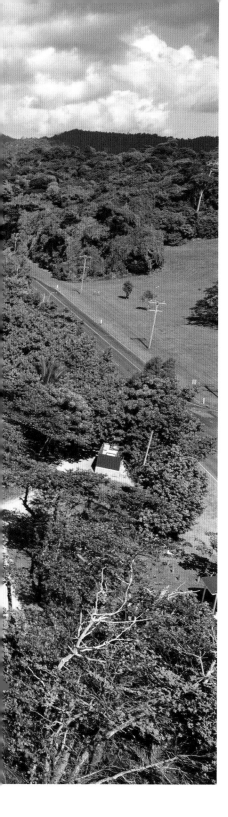

Mission Beach, the name given to a group of relaxed tropical beachside villages, is located between Cairns and Townsville in the Cassowary Coast Region. The four main settlements are South Mission Beach, Wongaling Beach, North Mission Beach and Bingil Bay. A series of palm-fringed beaches, stretching 14 kilometres, connects these four small communities from Kennedy Bay in the south to Garners Beach in the north. Dunk and Bedarra Islands, part of the Family Group of islands, lie just a few kilometres off the coast. Dunk Island was annexed by the RAAF during the Second World War, becoming home to secret radar equipment which played a vital role in the Battle of the Coral Sea. The locals referred to the area as 'the mission' due to an Aboriginal settlement construction being commenced in 1914. However, a devastating cyclone hit in 1918 destroying the few buildings in place and no attempt was made to rebuild. Instead, the people were relocated to Palm Island, and in time the name changed to Mission Beach. Today it is a charming, quintessential Queensland coastal set of villages and brilliant holiday destination.

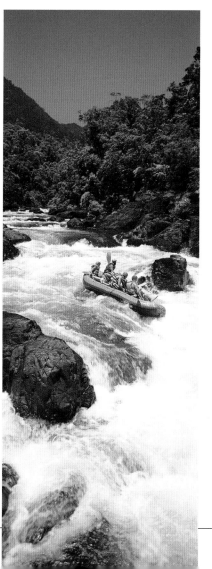

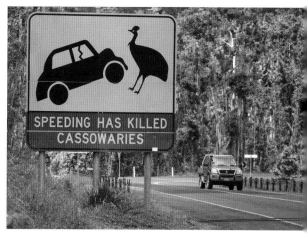

Above: Mission Beach has one of the highest concentrations of the endangered cassowary in Australia. They can often be spotted walking through fields, gardens, crossing the road and on the beach.

Left: The Tully River rises in the Cardwell Range and provides some of the best white-water rafting in Australia. Along with adventure, the river provides water for tropical crops.

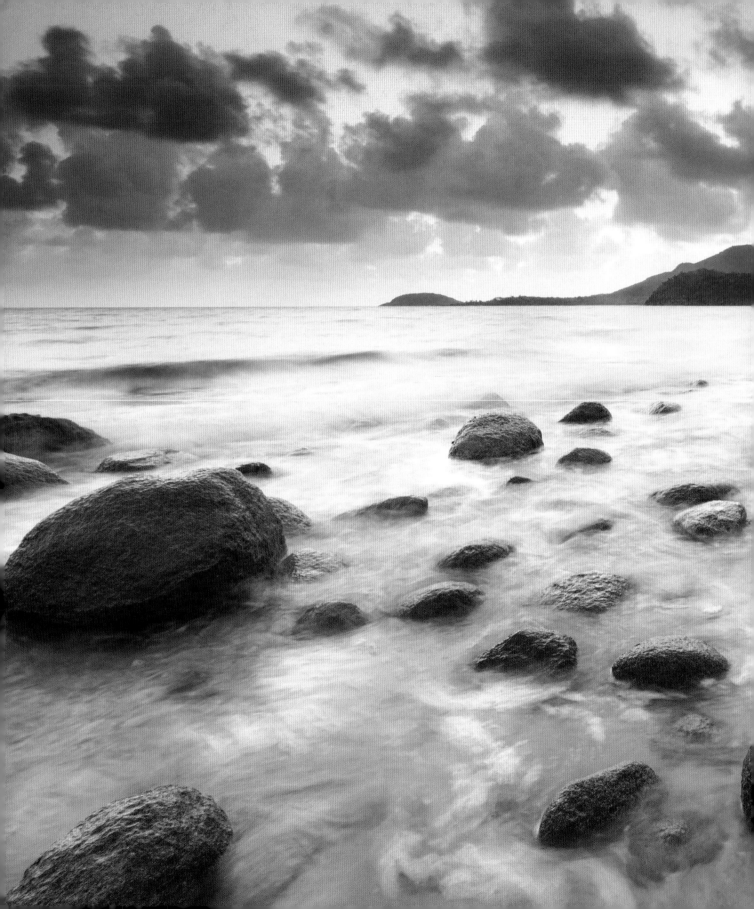

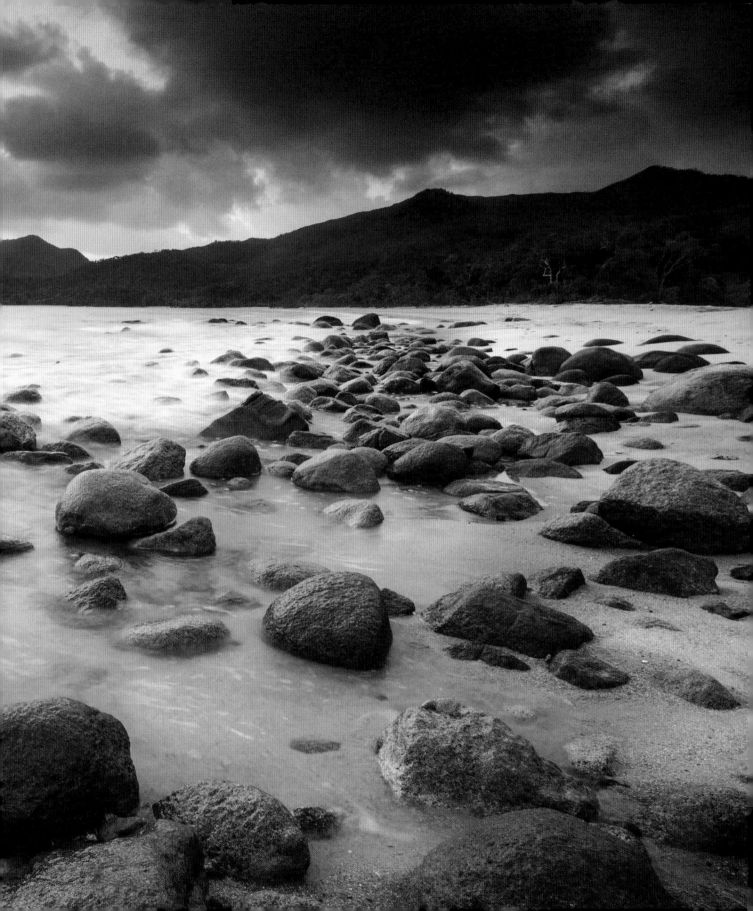

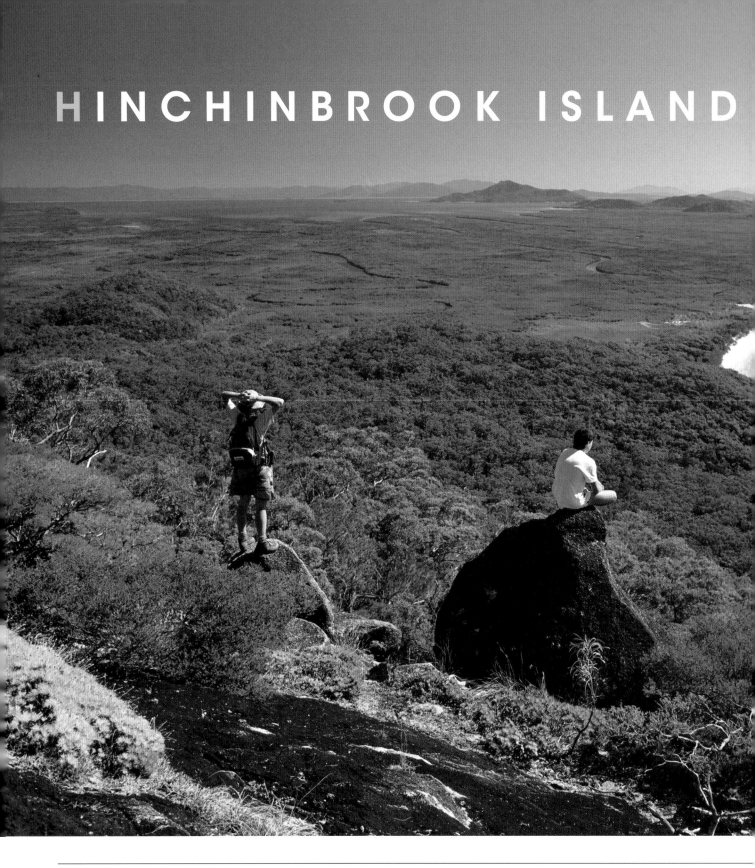

HINCHINBROOK ISLAND

Australia's largest island national park and the biggest island on the Great Barrier Reef, Hinchinbrook Island is entirely uninhabited. Separated from the mainland for around 100,000 years by the narrow Hinchinbrook Channel, the entire island is World Heritage-listed and believed to be one of the most diverse wilderness areas in the world. The island is recognised internationally for its extensive range of distinct habitats. There are heath-covered mountains, extensive woodlands, paperbark and palm wetlands, along with pockets of lush rainforest and eucalypt forest fringing the white sandy beaches. More than 29 species of mangroves have been identified, and the island is considered to support the richest and most varied of these salt-tolerant plants in Australia. In spring, the island heath erupts in wildflowers. Visitors are guaranteed to encounter wildlife with 150 bird, 19 mammal, 22 butterfly and 32 reptile species already identified. Various marine habitats such as mangroves, coral reefs and seagrass beds sustain a range of aquatic creatures including rare dugongs and turtles. Small areas of the island are open to only 40 visitors at a time to protect the unique environs both above and below the water. Middens and fish traps remain as reminders of the Bandjin Aboriginal people who lived here for thousands of years.

Previous page: Hinchinbrook Island, is no different to all tropical islands in North Queensland. Formed by ferocious volcanic activity, rising of sea levels and temperatures into a magical paradise.

Above: There are four walking tracks, from the short one-kilometre return Haven track to the 32-kilometre one-way Thorsborne Trail, named after local naturalists Margaret and Arthur Thorsborne.

Right: The blue banksia is endemic to Hinchinbrook and the adjacent mainland.

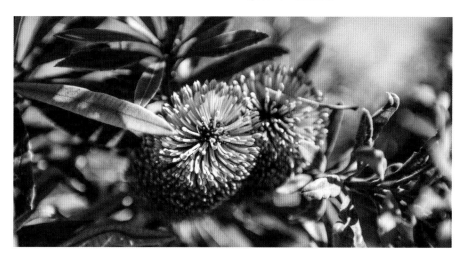

WALLAMAN FALLS

The highest, permanent, single-drop waterfall in Australia, Wallaman Falls is part of the traditional lands of the Warrgamaygan people. The falls, 51 kilometres south-west of Ingham, in Girringun National Park, form part of the UNESCO World Heritage-listed Wet Tropics. Stony Creek, a tributary of the Herbert River, tumbles over an escarpment of the Seaview Range. A series of falls descend through a small number of cascades before the dramatic 268-metre sheer horsetail drop into the pool below. There are two walking tracks. The 800-metre Bangguruu (meaning turtle) track leads you to a deep waterhole. Saw-shelled turtles are frequently witnessed basking on logs or peeking through the water. Swimming, while tempting, is discouraged to protect the delicate environment. The Djyinda (meaning falls) walk weaves through the rainforest to the base of the falls. Frequently the mist of the falls creates a rainbow effect and a photographer's paradise. Southern Cassowaries are frequently seen walking along the sides of the road on the drive to the falls. In breeding season, from May to October, they will often have chicks.

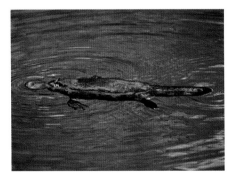

■ Above: Platypus live in Stony Creek and are best seen early in the morning or at dusk.

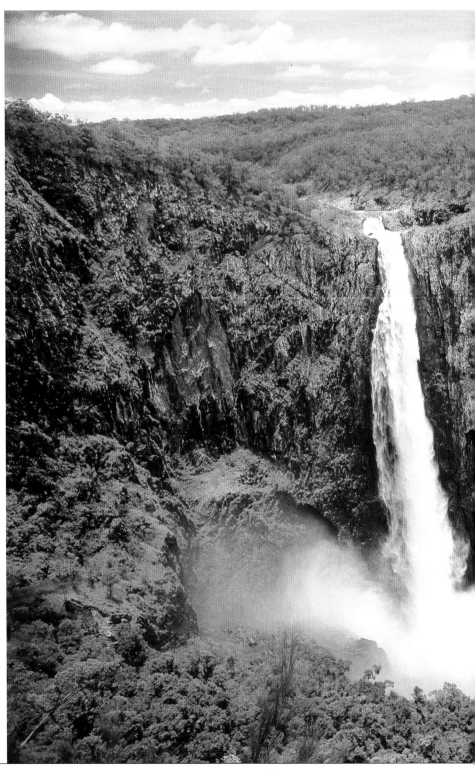

■ Left: The falls gush the greatest during the Wet season. Studies by James Cook University scientists found the world's cleanest water could spill over Wallaman Falls.

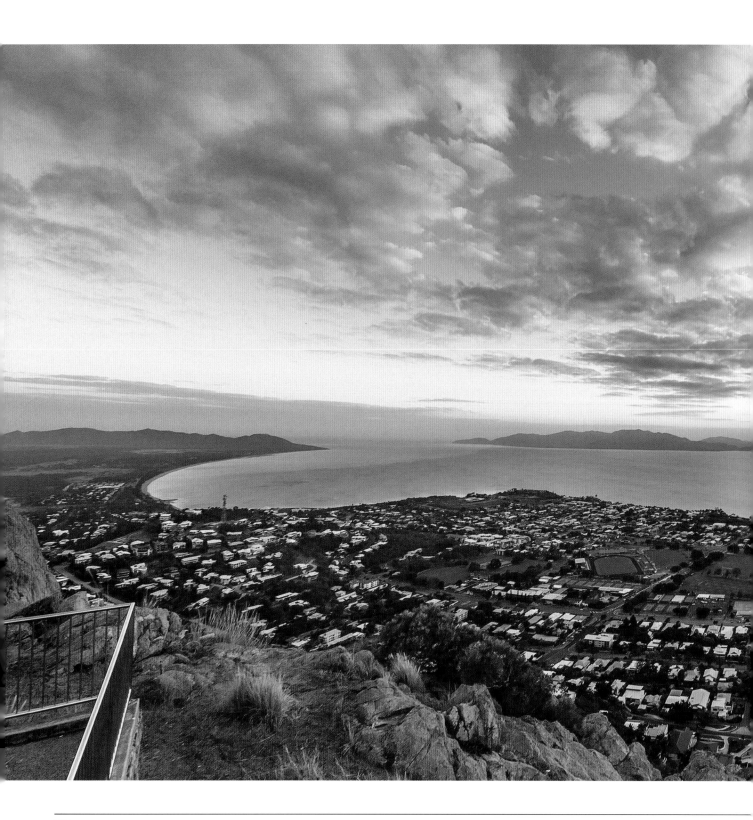

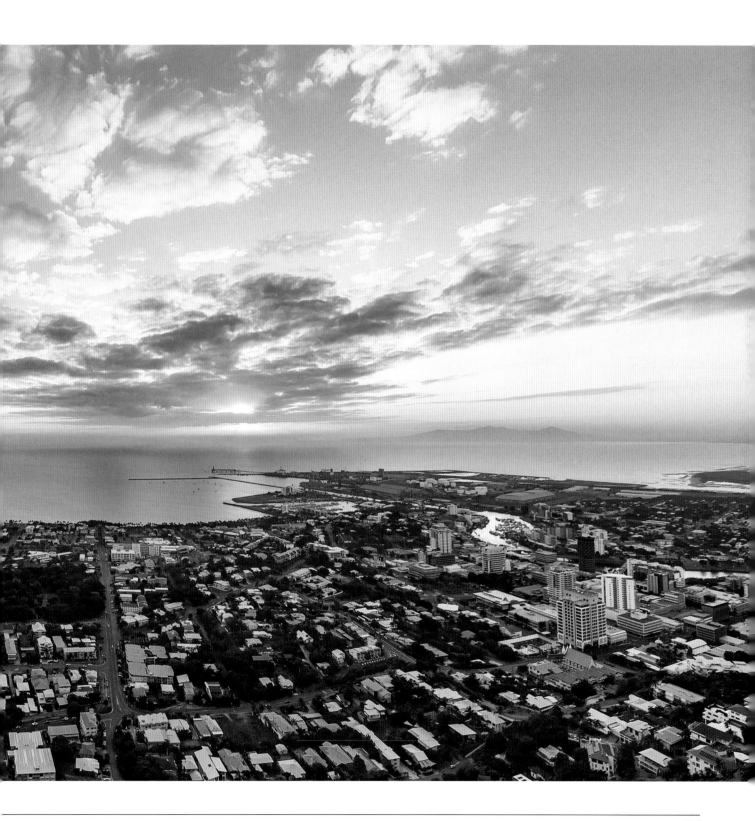

Northern Queensland's second largest city, Townsville, is steeped in history and surrounded by striking national parks and islands. Founded in 1864 as a port for the pastoral and mining industries, by the time World War II came around the city had become a major military base accommodating up to 90,000 Australian, American and allied service personnel. Bombed on three occasions, today it is a delightful city boasting the world's largest living coral reef aquarium. Magnetic Island, or Maggie as the locals call it, sits eight kilometres east of Townsville. It's basically another suburb of Townsville but with over half of the island protected as a national park. Surrounded by granite boulders and deep bays, the island is known as having one of the purest, disease-free habitats of koalas in Australia. Its name can be accredited to Lieutenant James Cook as his diary recorded problems with the ship's compass when passing during his 1770 marathon voyage. To the west of Townsville, is Charters Towers, a prime beef growing district, and the Burdekin region, known as the world's sugar capital. Nearby Charters Towers, a town steeped in history, was so rich after the discovery of gold it ran its own stock exchange. Grand buildings adorn the streets, and a short drive from the town is Dalrymple National Park with above ground ancient lava flows and graves of hard-working pioneers.

■ Previous page: From Castle Hill, a giant peak of pink granite towering over 275 metres, take in the views across Townsville, the ocean and islands. The hill's Indigenous name is Cootharinga.

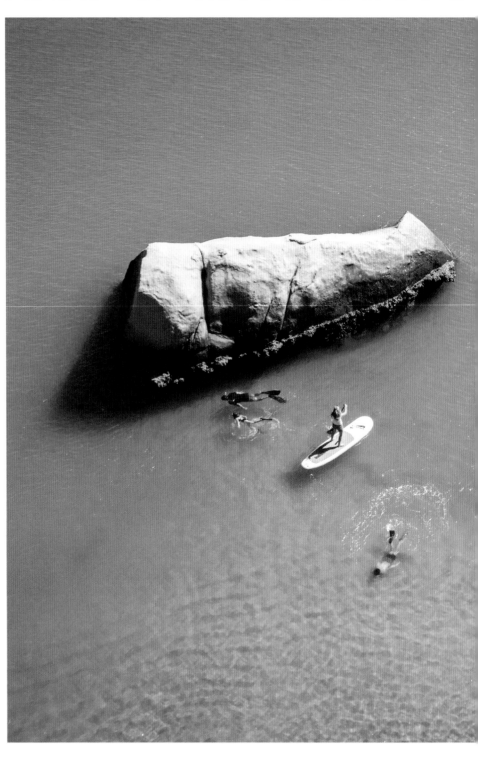

ISLAND

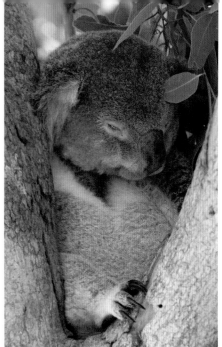

Left: Huge granite boulders separate Magnetic Island's beaches and bays.

Above: Koalas were introduced onto Magnetic Island in the 1930s to protect them from perceived threats on the mainland. The koala has evolved to become the only mammal that can survive on leaves of the Eucalyptus tree alone. This nutrient-poor diet means they must rest for up to 20 hours a day.

Below: Beef cattle are an important part of the economy of Townsville's hinterland.

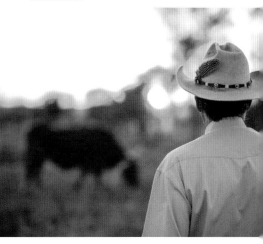

WHITSUNDAY ISLANDS

Turquoise waters, pure white sandy beaches and emerald green-clad mountains make the Whitsunday Islands a precious gem of Northern Queensland. The collection of 74 tropical islands sit in the core of the Great Barrier Reef and are unlike any other group of islands in Australia. Centred around Whitsunday Island, the most northern islands lie peacefully off the coast from Bowen, while the most southern is situated east of Proserpine. They were named in 1770 by Lieutenant James Cook who thought it was Whit Sunday, a Christian holiday that takes place seven weeks after Easter, however (it was in fact, Whit Monday as their ship had passed the international date line which had not yet been established). Once part of the Great Dividing Range, Australia's largest mountain range, the islands were isolated at the end of the last Ice Age. The waters rose and valleys were flooded, isolating the tips of the mountains to create the series of island wonders that have become a tourist mecca for visitors from around the world today. Some of the highest peaks in the Daintree Rainforest are Thornton Peak (1,374 metres and Queensland's fourth highest peak), Mount Hemmant (1,040 metres) and Mount Sorrow (743 metres). The region harbours rare plants and animals found nowhere else on earth, hence earning its listing as a UNESCO World Heritage–listed rainforest. The prehistoric ferns, emerald green vines and lush canopy have provided inspiration for many songs, poems and movies including the movie Avatar. This paradise, with a virtually unspoiled wilderness, can be easily explored by a tour or self-drive.

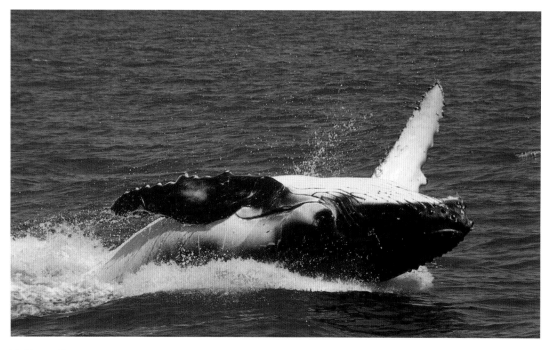

■ Above: Humpback whales migrate from Antarctica each year to calve and mate in the warm, peaceful waters around the isles.

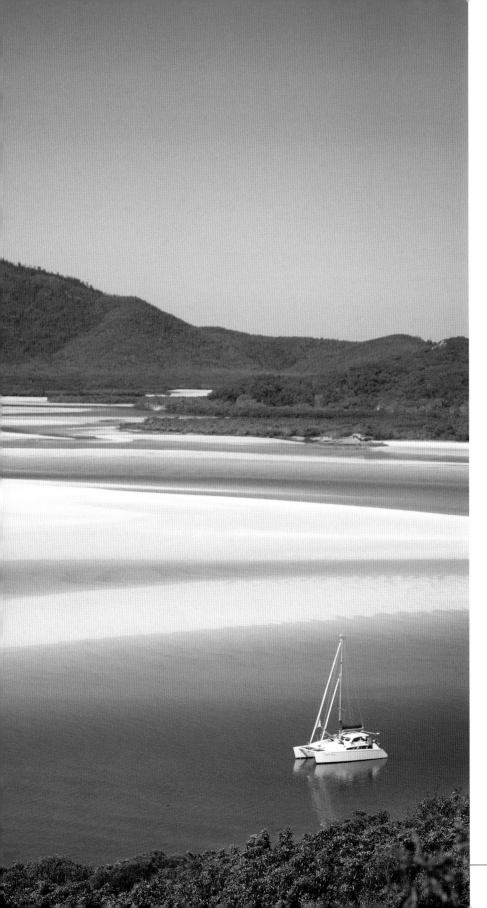

Left: Sailing remains one of the finest ways to experience the assortment of isles. Bareboating has become extremely popular as you don't need a license or prior sailing experience. Your boat becomes your own floating hotel with 360 degree changing ocean views.

Below: The majority of the Whitsunday Islands are uninhabited with only seven islands developed, some with resort accommodation. All are designated national park and many offer walking trails and camping at designated sites.

Following page:The Whitsundays are a series of continental islands which are unsubmerged parts of the continental shelf surrounded by water.

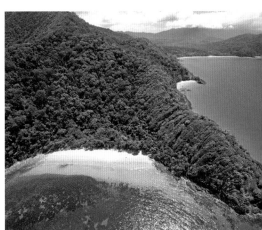

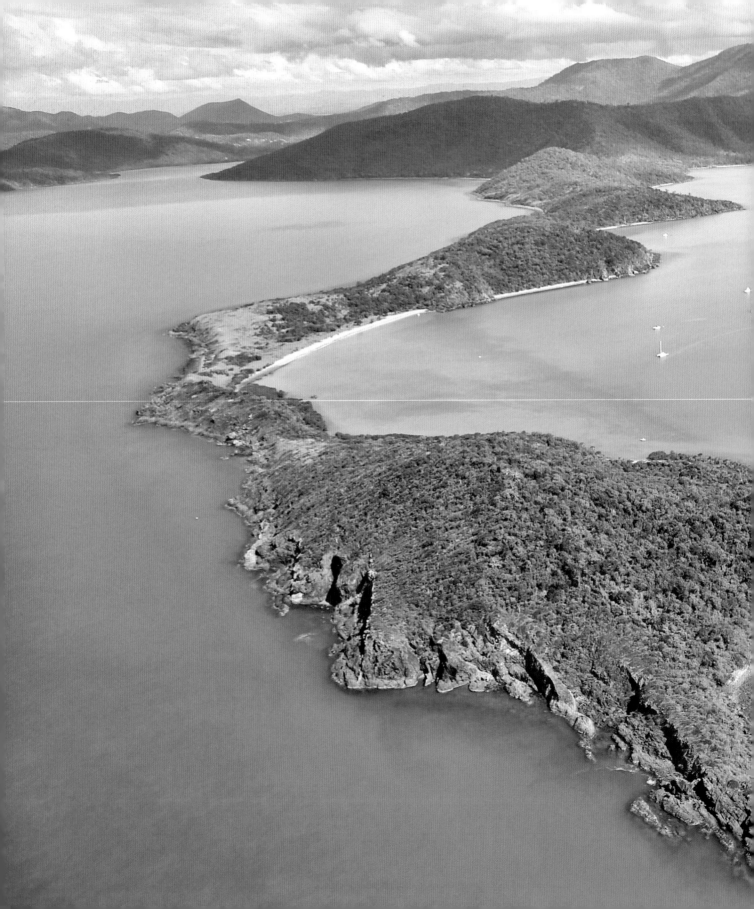

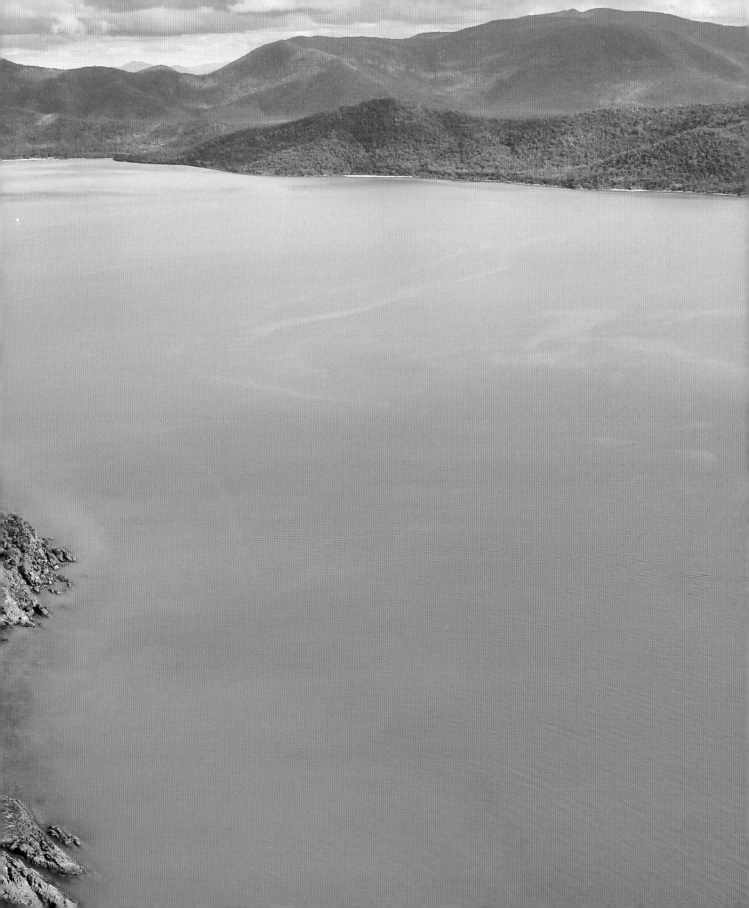

AIRLIE BEACH

This vibrant hub of the Whitsunday coast, surrounded to one side by the turquoise water of the Coral Sea and the other by the lush, productive hinterland is an intimate township and one of a kind. Shrouded in a fascinating Indigenous and European history, Airlie Beach is a thriving holiday town known as the Gateway to the Whitsunday Islands. In December 1935 the Lands Department for the Proserpine Shire Council was requested to provide a name for a new subdivision on the coast. Rumours concur that it is almost certain the town was named for the parish of Airlie, in Scotland, as suggested by the chairman of the former Proserpine Shire Council, Robert Shepherd (who was originally from Scotland). The official name from 1936 until 1987 was simply Airlie. It has developed into a base for travellers of all ages, with a range of eateries, live music, tours, festivals and many other fun activities, however the Whitsundays and the Great Barrier Reef are the key attractions. Day trips, long and short, escort you to an array of islands, secluded beaches and atolls around the Whitsundays.

Millions of years of the earth moving and changing demonstrate an insight into the tumultuous past of the region. The massive granite boulders at Mossman Gorge are one example. In other areas on the Daintree Range, metamorphic rocks, created by the physical or chemical alteration by heat and pressure of an existing igneous or sedimentary material into a denser form, show another contrasting stage in the formation of this region.

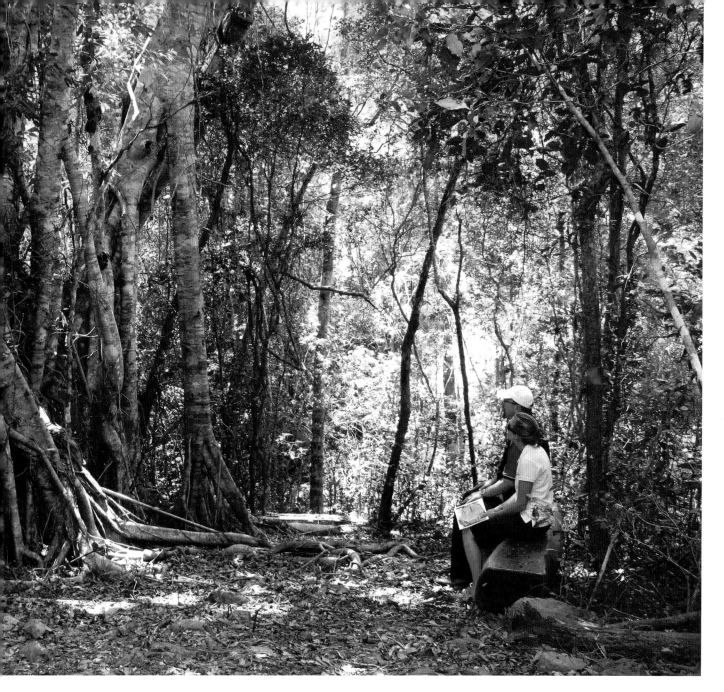

Above: Short and long walking tracks lead you into the cool rainforest around Airlie Beach.

Opposite page bottom: Airlie Beach, a land-based tropical playground and gateway to the Whitsunday Islands.

Left: A short drive from Airlie is the village of Bowen renowned for its luxurious crops of succulent Bowen mangoes. Along the road's farmers sell fresh mangoes from roadside stalls at bargain prices.

ACKNOWLEDGEMENTS

The author would like to thank all the talented photographers and experts on Tropical North Queensland that have contributed to this first edition. She would also like to personally thank Andrew Swaffer for his guidance and patience while compiling this edition. A special thank you to Shelley Winkel and the team at Tourism Events Queensland, Christine Schiedel at Woodslane for her remarkable diligence and creativity in the design process and to Australian Geographic for allowing me to undertake this special project.

ABOUT THE AUTHOR

Danielle Lancaster is an award-winning photographer and writer. Previous books include '4WD Treks Close to Brisbane', 'Out Around the Bulloo' along with her Walkley prize for her photo-essay 'Healing Cambodia's Wounds'. As the past president of the Australian Travel Writers Association, Danielle continues to work as a travel writer, photographer, teaching photography through workshops and tours along with public speaking. She is a founding member of the Global Travel Writers Association. www.blue-dog.com.au

ABOUT THE PUBLISHERS

The Australian Geographic journal is a geographical magazine founded by Dick Smith in 1986. It mainly covers stories about Australia - its geography, culture, wildlife and people - and six editions are published every year. Australian Geographic also publish a number of books every year on similar subjects for both children and adults. A portion of the profits goes to the Australian Geographic Society which supports scientific research as well as environmental conservation, community projects and Australian adventurers.

Woodslane Press are a book publishing company based in Sydney, Australia. They are the publishers of Australia's best-selling walking guides and under their co-owned Boiling Billy imprint also publish camping, bush exploration and 4WD guides. For more than a decade committed to publishing books that empower Australians to better explore and understand their own country, Woodslane Press is proud to be working with Australian Geographic to produce this new series of souvenir books. Also available:

All images are protected by copyright and have been reproduced with permission.

Front cover: Mike McCoy
Pi: Australian Geographic/Ego Guiotto
Pii: Tourism and Events Queensland/Jemma Craig
P1: Tourism and Events Queensland/Brad Newton
P2-3: Tourism and Events Queensland/Jason Hill
P3: Danielle Lancaster
P4: Danielle Lancaster
P5: Shutterstock.com/AustralianCamera
P6-7: Australian Geographic/Drew Hopper
P7: Tourism and Events Queensland/Jesse and Belinda Lindemann/Matt Glastonbury
P8-9: Quinn Lawson/www.quinnlawsonphotography.com
P10-11: Tourism and Events Queensland/Cathy Finch
p11: Danielle Lancaster (both)
p12-13: Australian Geographic/David Dare-Parker
P13: Tourism and Events Queensland/Peter Lik
p14-17: Tourism and Events Queensland/Cathy Finch
p16-17: Tourism and Events Queensland: Andrew Watson; Chris McLennan; Krista Eppelstun
P18-21: Quinn Lawson/www.quinnlawsonphotography.com (crocodile); Shutterstock.com/electra (termite hill); Danielle Lancaster (butterfly, frog & glider); Tourism and Events Queensland/Gary Bell (underwater); Australian Geographic/Don Fuchs (cassowary)
P22-23: Tourism and Events Queensland/Darren Jew (Idiot tree flower); Danielle Lancaster (Pitcher plant);

Australian Geographic/David Hancock (flowers); Tourism and Events Queensland/Richard McKenna (palms)
p24-25: Tourism and Events Queensland/Jemma Craig
p26: Australian Geographic/Kevin Deacon (spawning); Australian Geographic/Mike McCoy (coral); Tourism and Events Queensland/Mark Fitzpatrick (turtle); Tourism and Events Queensland/Andrew Watson (reef dive)
P28-29: Tourism and Events Queensland/Peter Lik (road); Australian Geographic/Mike McCoy (birds)
p30-31: Danielle Lancaster
P32-33: Tourism and Events Queensland/ Darren Jew (rivermouth); Tourism and Events Queensland/Peter Lik (boulders); Tourism and Events Queensland (Capt Cook); Tourism and Events Queensland/ Darren Jew (hotel)
P34-35: Tourism and Events Queensland/Damon Smith (forest meets sea); Tourism and Events Queensland/Tony Gwynn-Jones (flower); Tourism and Events Queensland/Darren Jew (river); Australian Geographic/Andrew Gregory (bird); Tourism and Events Queensland/ Darren Jew (forest detail); Shutterstock.com/ProDesign Studio (forest overview)
P40-45: Tourism and Events Queensland/Peter Java
P42-43: Tourism and Events Queensland/Vince Sofia (Cairns); Tourism and Events Queensland (waterfall);

Tourism and Events Queensland/Tony Gwynn-Jones (flower)
p44-45: Tourism and Events Queensland/ Vince Sofia (beach); Tourism and Events Queensland/Peter Lik (rafting); Tourism and Events Queensland/Chris McLennan (kayaking); Australian Geographic/David Bristow (sign)
p46-47: Australian Geographic/Bill Bachman (main image); Australian Geographic/Drew Hopper (flower)
p50-51: Tourism and Events Queensland/Peter Lik (wayerfall); Tourism and Events Queensland/Murray Waite & Assoc (platypus)
p52-53: Tourism and Events Queensland/Aaron Spence
P54-55: Tourism and Events Queensland/Matt Raimondo (boulders); Danielle Lancaster (koala); Tourism and Events Queensland/Lauren Bath (farmer)
p56-57: Tourism and Events Queensland/Keiran Lusk (aerial 1); Danielle Lancaster (breaching); Tourism and Events Queensland/Vince Sofia (aerial 2)
P58-59: Tourism and Events Queensland/Mike Hilburger
P60-61: Tourism and Events Queensland (trees); Tourism and Events Queensland/Mike Hilburger (town); Tourism and Events Queensland/Tony Gwynn-Jones (mangoes)
Back cover: Tourism and Events Queensland/Peter Lik

PICTURE CREDITS